EXHIBITIONIST

Praise for *Cover*

"An uncanny talent for capturing entire books with succinct, compelling imagery—a talent that has led some to deem him the best book designer of his generation."
—*WIRED*

"Peter Mendelsund pushes the visual and the verbal into unforeseen alliances. Once we've seen these alliances, they feel inevitable. He establishes exactly the right balance between the timely and the timeless. He engages with all the fashionable tropes, trills, and frills of our on-the-go culture, while remaining grounded in a rigorous formal logic."
—*The New Republic*

Praise for *What We See When We Read*

"Mendelsund is an adept memoirist; the personal material in this book resonates. He notes that we can read novels quickly, as if driving through them, or slowly, as if walking, and have distinct experiences . . . [He] keeps his tone light while thinking deliberately about fundamental things."
—*The New York Times*

"*What We See When We Read*, itself a work of conceptual design, unfolds the author's ideas about what makes reading a creative, visual act all its own on pages— some packed with text, others just a line or two—that incorporate sketches, clip art, images of classic book covers and more."
—*The Boston Globe*

Praise for *The Delivery*

"Peter Mendelsund's *The Delivery* is not only truly original, and gorgeously written, it shines a light on a person, a population, generally invisible to all but themselves, which is among a novel's more profound purposes. It's a remarkable book."
—Michael Cunningham, author of *The Hours*

"Mendelsund explores identity, community, and the past's power to influence the future in his stunning latest. The author's playful sense of form and command of language make for an original and provocative novel."
—*Publishers Weekly* (starred review)

Praise for *Same Same*

"Peter Mendelsund's first novel manages to be breezy and profound in equal measure, and the balance turns this homage to Thomas Mann's *Magic Mountain* into a clever metafictional sendup of artists' retreats and tech-industry think tanks . . . Some of the most perfectly tuned passages of fiction I've read in a long time."
—*The New York Times*

EXHIBITIONIST

1 Journal
1 Depression
100 Paintings

PETER MENDELSUND

Catapult
New York

EXHIBITIONIST

This is a work of nonfiction. However, some names and identifying details of individuals have been changed to protect their privacy, correspondence has been shortened for clarity, and dialogue has been reconstructed from memory.

First Catapult edition: 2025

ISBN: 978-1-64622-289-6

The Library of Congress Control Number is available.

Cover design by Peter Mendelsund
Book design by Peter Mendelsund, Laura Berry, and tracy danes

Catapult
New York, NY
books.catapult.co

Printed in China

10 9 8 7 6 5 4 3 2 1

For my mother, with all my love

1.

Rain on the drive. The undersides of the leaves were bright. Coming up the road, the barn was the first thing I saw. Large, almost black; presiding over a farmhouse, shed, a murky pond, and a large, untended field that stretched off and off.

Unpacked. Searched the property. Sat on the porch steps.

The stockade of pines. Miles of woodland. I'm in for a lonely time. Amazed by how isolated it is. And everyone I know here is too afraid of the disease to fraternize.

(But: no one for whom I must perform well-being.)

The world and I: infected. Retreating inward. Consoled that no one, anywhere, is happy.

I am clinically depressed, depressed beyond measure, and it shows no sign of abating. I am dangerously depressed; this is how I think of it. After so many episodes like this one, I know dangerous when I feel it, and this one will be too large to vanquish.

2.

Remembering the fall when it snuck in. Unnoticeable at first. Then one day I woke up and the world promised nothing but violence. Clocks were screaming, the sun was filthy, the air scoured my lungs, my balls ached, my feet were cinder blocks. After that I began to speak in sawdust (when I spoke at all). I had no gifts to bestow, and no points of contact. I felt neither happiness nor anger, humor, sadness, friendship, enmity, belonging, love. Only dread.

3.

V. and R. choosing bedrooms. The depression seems to have had little effect on them. They have teenage concerns, and who can blame them. I've become a gauzy presence in their lives.

K. worries about me, naturally.

"I'm handling it," I mutter; an asshole.

Dinner eaten; dishes done; bed. Awake until gray light.

Exhausted today. I visited the barn. Cedar smell, high in the nose. Walking in there was like entering a cave. Murky, musty as fuck.

Turned on the lights. Old wooden table, derelict motorcycle, rickety bench, barrel of mulch, chainsaw, rudimentary bathroom, little else. On one wall was a dartboard. Left.

Today I went back in, shut the enormous door, and for some reason latched it. Played darts against myself; lost every game.

I walked in the upper field. A sky so blue it came across as aggressively middlebrow. This depressed me further. Wet feet.

I watched the pond, looked for the sky's reflection, but the water was the color of nothing.

A heron came. It bobbed in the reeds, looking for frogs to spear. Jealous of its stupid single-mindedness.

Small songbirds. The climate and topography are perfect for them. Plenty of food, good sight lines. But they never shut the fuck up.

A flock of geese parted the waters like a plow.

Hot today. Felt terrible. Nothing else.

4.

The geese have been here three days now, honking and shitting. The little ones eat out in the grass, the two parents vigilant as periscopes. Later in the day, they are gone. A small gosling remains—barely grown out of its fuzz and into its feathers—it limps. I see it now, struggling on land, unable to spend the whole day in the water for want of food. I am hoping it will graft onto another flock. I listen for honks from over the hills. None come. Today the gosling tried to bond with the heron, its distended, uncanny cousin. The heron wanted nothing to do with it. It seemed irritated. Or at least unmoved, and eventually it unfurled its enormous sails and was gone.

Something people like to tell you about geese—false, it turns out—is that they never leave a member of their flock behind. In fact, they are mistrustful of the injured, their urge to migrate overtaking all other urges.

Today I searched for the gosling by the pond, out in the field, and thought: it is surely dead by now.

I am not following the news. I don't watch movies or television. I don't read. I stopped reading months ago. Still, I'll pull a book down, open it at random, read a sentence, feel disgust, and put it back. (Does this count?)

My new novel is coming out. I am of several minds about this. I think it's a pretty good book (on occasion). I think this, though I would never say it. So there's some (private) pride. But mostly fear. I've never published a book that, upon being made public, did not cause me an unusual level of anxiety (I am a fraud, etc.). But putting this aside for a moment, with this book I am specifically worried that people won't like my narrator.

5.

This house is old. Everything that happens here triggers a creak, moan, crackle, complaint. Tiptoeing is a joke. And to think that I believe the older I get, the better I become at keeping my pain close; private.

Family to town. Walked in the woods. Several empty hunter's blinds.

Today—in tatters. The day is lead. My head is lead. The world is lead. I have lead poisoning.

At the edge of the wood
The silent field before me is hollow.
Who has ever been so alone?

Once, when I was a teenager, and everything was falling apart, driven by confusion and grief, I took a trip alone to the antipodes. That first night, alone, under the largest sky I'd ever seen, I looked up to see the constellations upside down. The Dipper spilling its contents. It is like this now. I feel that alone. Even (especially) when surrounded by people who love me.

Acrylic, coffee, rainwater, olive oil

Acrylic, interior latex paint

6.

V. discovered the barn. We spend time in there together, mostly playing darts and contesting points. Her heatedly, me halfheartedly. This is, I think (misusing Wittgenstein's phrase), a "form of life," and I also try to view it as a form of progress. Boy, do I love her. This love gets through the fug, somehow. But the love is manifesting—like everything—as fear. Fear over her well-being and guilt over my not being thoroughly present.

Can't keep up the pretense of health anymore. And then I keep trying. I'm writing this out on stone steps made, appropriately, from old millstones. I hear V. in the barn. She's playing darts by herself, just as I did. I hope, unlike me, she is winning.

Where can I hide now that my territory has been annexed? I take my therapy sessions in the house, in a downstairs bathroom. This is the second most private space on the property that still has a Wi-Fi connection. But this bathroom, which adjoins my bedroom, lies too close to well-trafficked hallways to make it truly private.

I whisper, and am wary.

Hunched on the bath mat, lower back against the bathtub, holding a phone up so that my therapist and I can look at each other. The toilet just out of view to the right. The mat keeps sliding on the tiles, so I am getting lower and lower on-screen. I have to put one foot on the doorframe and another on the sink pedestal and push my way back up to sitting. This has happened several times during our session. I have just realized that when I do this spread-legged maneuver in order to

right myself, I rock a bit side to side, a movement my therapist surely sees. She may think that this (davening?) is a nervous tic. Also, because of the rocking, the toilet briefly becomes visible on-screen. Not ideal. But a more accurate picture of my abjection than mere months ago, when I was sitting in her Eames armchair, dressed for work, legs crossed, eyebrow cocked, the very picture of a real man.

Vaguely aware of time passing. Days like the version history of a novel: one that isn't working.

F. met me outside at the house. Masked. We walked around the pond. He told me I seemed sad. And I did. One of depression's outward forms is sadness. Depression is a language: frequently mistranslated. But if this were sadness, I would feel better having expressed it. (Depression's other outward form is affectlessness. Looking sad is better.) It was futile, but F. tried to get me talking.

I have found solace in sadness; even in the acute sadness of mourning. This depression though: there is no relief, as there is nothing to be relieved of. It is emptiness.

(Everyone, compulsively, tries to cheer me up.)

In a new development, today's cry was in public (though not in front of my family). No one in the store seemed to care. Maybe these strangers assumed I was tired, high, or allergic. I suppose that only red-eyed women have been crying. Especially in these hard, rural towns.

I have a taxonomy for cries: "wet" and "dry" ones.

Two months of pandemic, and I've already ceased
to take solace in it. It doesn't matter anymore that
the whole thing is an uncanny analog to my own
condition. This is because, having contacted some
friends yesterday, I learned that: (1) People are adapting;
finding ways to be happy. (2) Those who cannot adapt
are becoming depressed—and not to get into a pissing
contest here—but that is *my thing*.

7.

I do not think I will ever be able to write again. I despair
over this before realizing, reading these few entries
over, that I am writing. The sentences here are like the
ones in my fiction, using the same vocabulary, rhetoric,
rhythms. A habit, I suppose.

Went to visit the nearest bookstore, which is a forty-
five-minute drive from the house. Mostly used books on
baseball and fishing. My breath was ammoniac under
the mask, so I left. I wasn't going to buy a book anyway.
I just thought it might help recall better days. Instead,
it elicited a grim reminder that my novel's pub date is
approaching. Added to the sum of ambient fears. I tried
to push it from my mind. Left the bookstore and went to
Home Depot.

The car was blistering.

Oil, acrylic

Acrylic

8.

A state divided ideologically. Home Depot is a sort of general assembly for its right-wing constituents. The place was crawling with lumpy, red-faced white men. Aggressively maskless. MAGA shit. In the hardware aisle, looking for nails, I saw a man with a neat row of variegated jowls. The rest of the men looked like raw hamburger meat. I felt I was in danger. That they could sniff the liberal on me. Kept my head down.

Back in the car, on the strip—passed gas stations, Hot Topic, Dunkin'. There was a Michaels. I pulled in. Inside it was all women. Faded, defeated; like me. All we have is our hobbies; something to keep our hands busy, the only thing the world can't touch. When Ragnarök comes, I, and these women here, will be too busy crafting to even notice. (I have become unkind.)

Twenty minutes later, I came out, carrying several prestretched, primed canvases, five bottles of cheap spray paint, some pens and pencils, and two baskets of acrylic paint in multiple colors. U-turned, returning to Home Depot to pick up a tarp, some trowels, foam brushes, and a bunch of PVC buckets.

No idea why I did this.

K. opened the paper I bought her in town, then relaxed her grip. Peeking over the parapet, she asked how it went. I gave some minimal, mopey reply. She nodded. Pulling with both hands, she snapped the bad news open again.

Oil, acrylic

Oil, acrylic

9.

Growing up, the only kids I knew who kept diaries were girls, as if the idea of the chronicle was female in nature. And I thought then that the thoughts of girls in particular were necessarily dangerous, as they are kept under lock and key. Protected, but also fettered.

I did not like remembering, so avoided setting things down, and spent my energies imagining what wasn't. I'd enact fictions with my toys.

Thinking of this journal/diary as a kind of medical chart. The medical chart of a patient who is alone in an empty ward in an empty hospital in an empty world. I am never examined by a doctor. There are no rounds. No nurses to change my drips. No procedures. Appropriately, I stow the diary at the end of the bed (in an old blanket chest). But this bedroom is not really a hospital in any way except for the medicines. My many medicines.

Should I list them in my chart? All the substances— controlled and otherwise—I am currently putting in my body? A list for myself? For my wife? For my friends, in case they want to hold an intervention and need to know why they are intervening? For future psychiatrists or doctors? For a headlong posterity? I can't though. I fear the list would be too . . . sobering.

Walk in woods. Sprayed a wasp nest under porch. More of my hair in the bathroom sink. Still sloughing.

(What is the difference between a journal and a diary? I realize I don't know.)

Didn't eat today. I look so thin, it—this severity—makes me handsome. What a waste.

Can hear an engine, deep in the forest, moving around the logging paths.

10.

Percocet.
Oxycodone.
Codeine.
Alcohol. Lots.
THC, CBD, etc.

1 SSRI
2 benzodiazepines (one of which is legitimately
 prescribed)

11.

What isn't prescribed I've squirreled away over time. A prepper; a *survivalist*. I've faux-casually asked friends for their extras. I've stolen painkillers wherever I could find them. Rifled drawers and medicine cabinets. I've contracted sudden, acutely painful back conditions of mysterious origin, conditions only alleviated through the administration of palliatives that were (once) so easy to procure (for a reasonably well-to-do Caucasian man). There are ways and ways. No one, not even K., has any idea of the extent of it. If they knew, they might take it all away from me. Unthinkable.

Still, there isn't enough. The Percs in particular. The supply feels measly. And I need it to last. Though it should get me through the month at least. I hope.

Medicines: occasional, but ever more frequent, self-administered punches to the side of my head. Sometimes I will punch my chest. This violence counts as a medicine of sorts. (NB, I punch myself in the chest when I believe that my troubles originate in *feeling*. The head blows are for when I have diagnosed the problem as *thought*.) By disclosing as much—this compulsion—I punch myself here too. Even in this diary. Even here.

Along with the style of the thing, the process here in this journal is also similar to the one I use when writing books. Material arises. There it is, my material, right over there—there it is, then it's gone, though it leaves a kind of phosphor trail. A lingering shape or impression. The material stands out by virtue of standing out. It seems always already meaningful. Such material (in the case of this journal: the contents of the day) is set aside to be repurposed.

Acrylic, spray paint, Sharpie

Oil, acrylic, pencil, Sharpie, ink

I hear the chirrup of tufted titmice outside in the apple tree. P., my birding friend, tells me to recognize its call as "Peter, Peter, Peter . . ."

That's what it says in the birding books.

Is this all we find in the world? Ourselves?

12.

Journal: writing from. But not writing to. Journal-ism: my condition should be headline news.

F.'s clogs, dirty snow, wambling bat, urinating dog, branches intertwining to frame the moon, the daily flavor of my pain, long grass flashing white in strong wind.

Groceries. In line, the guy in front of me chatted up the cashier. I wanted him to hurry up more than I've ever wanted anything. I would've killed him if I could have. He would have killed me first though: he was telling her that he buys and sells war paraphernalia/ memorabilia online. Bayonets, flintlocks, uniforms, helmets, entrenching tools, mortar shells, gas masks. Interestingly, he wasn't merely relaying this information to her; it was a come-on.

Went on a solo drive to nowhere in particular. On the way back, the art supplies—the ones I'd bought on a whim—rattled in the trunk. One of the buckets must have tipped over. Every time I stopped at a light, it thudded, then rolled to the back again. I went into the house carrying the bags of food, leaving the art supplies to bake in the car.

"You seem so sad," P. says. Again with this. What is it about depression and repetition? Did things recur less often when I was happy? Now, the world is made unhappily anew yet identical each day.

"Should we all watch a movie?" I am running out of ways to say no. At my lowest, a movie doesn't make me feel anything. And when I am feeling even slightly better, it

makes me feel too much. Gibbering (wet) cries. This sensitivity is probably why I don't read anymore either.

Each of these days ruptures the last. Can't get a handle. I thought the meaning in all this was elusive, and then thought it was hidden or coded. I now believe it is absent entirely.

Q: Did Sisyphus have to spring out of the way of the rock each time he summited? Presumably he was behind the rock on the way up, so it probably rolled over him. Insult to injury.

(I am a fucking *delight*.)

13.

No recourse this a.m., went to the barn again. Though I found myself going to the trunk of the car first.

I flicked on the lights. Dumped the supplies on the barn's floor.

I was a graphic designer for almost two decades (an aspiring classical pianist for almost thirty). I've never made a real painting before in my life.

An "artwork." "Fine art."

Art was Dad's thing. At least it was during that last, terrible decade of his life.

It should help, this heredity.

Yet I have no idea how to paint. No idea. What is the first act one performs? You'd think I'd know *something*.

(I took art classes as a kid. This, I feel, doesn't count.)

Acrylic, pencil, coffee, dirt

Acrylic, pencil

White: when I looked at my new, unblemished canvases, a strange image arose—a phrase really, which was that I was "in the docket." Felt bad. Left.

Nothing today. Couldn't leave the house.

Another bad one. Another slash through the calendar.

Worse. World shrinking. My footprint shrinking. Ambit narrowed. A bed. I'm in bed. In bed. How long can this go on?

"Christ, I'm in pieces," I say to F., but then I remember the title of that debunked memoir from several years back.

Out on the steps of the porch today. I'm outside at least. The frogs in the pond are going berserk. My anxiety has reached a level such that it almost covers over the depression. Despair, but also now a throat-constricting terror. Back in the bedroom I'm pillow-strangling. The masochist never taps out.

This novel of mine. "Isn't it SO exciting?" I'm asked (told).

Alone at the gas station at night; mosquitos and midges swarming around the lights. As I wait for the pump to ding, I look up and there is one of the largest spiders I'd ever seen. You can't believe how big this motherfucker is. Black, smooth, and oily. I'm horrified. I leave the tank half filled. Tear the hell out of there. Then I'm driving, convinced that the horror landed on me before I fled and is about to burrow into my ear canal. Louise Bourgeois once had an exhibition at Books & Co, where I worked for several years. Spiders, predictably. The ones she called *Maman*.

Vampires, spiders. Vermin. Ungeziefer.

"My writing was all about you." Kafka about his father. "About," but I'd imagine "for" as well. ("To.")

Does everyone have an imaginary audience? In mine, there are those I want to please and those I want to impress; I feel I need to prove something to them. Then my idols—those I admire. The sophisticated, the intelligent, the keen. Those with their fingers on the pulse. Those in positions of power; who can help me get a leg up. Naturally there are those I feel deserve a comeuppance. (Critics; unsupportive family members; ungenerous or rivalrous friends. Those I am jealous of.) They are dispersed throughout the pit, the galleries . . . The show is sold out. I take this crowd with me through my years, theater to theater, performance to performance. People are added. Sometimes—if rarely—subtracted. Today I imagined them all dead. (Kill your darlings.) What happens then? To my work? My desire to make art? What happens to my attitude toward the work I do make?

Sometimes I imagine that my mental theater is attended by a sole spectator. He's sitting in a central loge, looking down on me like some kind of dark and capricious monarch. ("All my writing was about you . . .")

Acrylic, mud, olive oil, pencil, rainwater, whiskey

Acrylic

14.

No proper curtains in this bedroom, so I wake early. I have a moment—brief, before my brain secretes its daily poisons—when I think, oh god it's beautiful. Land of contentment. Annoyingly so. Farming communes, pizza ovens, mountain lakes, wood-stacking parties, maple tapping, cheese tastings, puppet shows, cider presses, saunas, Labradors, sheep. Great place: great place to live. "Great places to live" are hard on depressives. (Are they are also hard places to make art?)

Rain again today. Incessant wind. Leaves clatter against the siding. Lost two screens on the porch. Chairs toppled. Took the cushions in. Branches on the ground. The birds went wherever birds go.

"Trauma." I get cranky about this word, like the old man I am prematurely becoming. But shouldn't there be some bar to clear? I think this and also think that if there were a bar, my trauma wouldn't clear it. And so Binjamin Wilkomirski drifts into my thoughts. How he was exposed, pilloried.

With Wilkomirski I recognize a type. I had compulsive liars in my family, exaggerators, fabricators, and I also grew up among secrets. As a result, I had to work to learn how to tell fact from fiction. It wasn't easy. It still isn't sometimes. But I think what was compelling in Wilkomirski's story—what so interests me (then, as now)—was his unwavering belief in his false (debunked) memories (of having survived the Holocaust). He was, I think, relieved to have found an outsize explanation (world-historical tragedy) to account for his outsize grief. His trauma. Yet, the source of this pain was an ordinary one, pedestrian, banal:

the alienation he felt as a result of his having been adopted. Perhaps. Or maybe it was just run-of-the-mill depression.

15.

The local radio station plays Schumann's *Träumerei*. The Horowitz recording. I used to listen to this very performance on my grandfather's LP; popped and staticky. I played the record a million times. I've performed the piece on the piano many times myself. Such a lovely piece. So soft. Tender, intimate. When I was younger, I thought that the title meant "little trauma" ("kleines trauma"). It actually means "dreaming." I think that I can't listen to music anymore. It's too hard. Okay, so that's gone too.

I am remembering a book; there was a man who wanted to learn how to play the piano. But only wanted to learn how to play the *Träumerei*. That's it. Just that one piece. I hope he got there. It must have been a difficult piece for a beginner to master. But also: there would have been no pressure on him to succeed. Perhaps he played the piece poorly but could still hear the right notes, perfectly played, haloing each missed one. Maybe that was enough.

Roland Barthes was an amateur pianist. The last thing I read before my depression and my great renunciation of books was *Roland Barthes by Roland Barthes*.

Acrylic, spray paint, canvas remnants, pencil

Acrylic, acrylic pen, pencil

Diptych: Acrylic, acrylic marker, spray paint, pencil,
coffee, whiskey, dirt on linen

RB: famous mama's boy. These late works read like hauntings. The book is also a journal. Yet he is uneasy with the idea of a journal or diary. Uneasy about disclosure. I get it. Jesus.

Barthes, on published diaries: "Diary: diarrhea." (He wrote this in a book that is, itself, again, structured like a diary.)

Last fall, in my mother's living room. She and I were discussing a popular memoir. She said: "I don't like that. Why go on about yourself, about your past? Memoirs are so exhibitionist." She may be right. I think she's right.

Perfect title for a memoir though. Especially an artist's memoir.

I went back today and fixed the grammar in my first entries.

16.

I drive past a stubbled field, freshly harvested. Two cop cars parked by an embankment, sirens on. I slow, roll down my window, and ask what's up. A man was run over by his own tractor. I see the tarp out there. How the fuck did that happen. I try to map it out, this accident. Map it out forensically; determine the timing, blocking, mechanics, etc., and cannot. Unless of course: this was his chosen way to go. It would not be my first choice. I would not like to be *threshed*. Well now. Every idyll hides a secret woe.

Nasty out again. Brown and gray. More rain. I stood on the porch, nose graphed by the cold screen. I counted how many days have gone by since I bought the art supplies and recognized that my only accomplishment was to have moved them from one place to another. But then again, what have I accomplished through writing the last novel? All my work may, in the end, amount to absolutely nothing. Or worse. Not just pointless but actively irritating.

(Swarm of gnats by the well.)

A large animal shot from the forest line and raged into the back field. I worried for a family of turkeys I clock every day waddling out of the woods. I couldn't see above the high grass, so didn't know what would happen next. I also couldn't see what kind of predator it was, though as it came on in a blur, I saw it was honey brown and big as a hunting dog. Pointed ears. I've settled on mountain lion, though it could've been a bobcat. Either way, the scene is quiet now and the aftermath hidden. This particular field is now a site of violence, and of future, potential violence, and I can no longer recognize what was, only minutes before, a hazy, nondescript spot. I think: no amount of nostalgia will bring it back. It and the predator are inextricably linked. I think of the words "figure and ground," an art term, though I do not know what it means, technically.

Publication looming. Waiting for the book review of Damocles to descend and have taken to making fires. So many fires. It is the dog days of summer, and there is no time of day or even night that isn't uncomfortably warm.

I watch for another act of predation.

17.

Today, a moment as mysterious and unbidden as that which led me to buy these art supplies in the first place: I went out back to the woodpile under the barn. I was looking, it turned out, for something inferior—less white, less pristine—to practice painting on. There was a four-by-four-foot plywood sheet. It was moldy and a bit warped. Heavy. I pulled it out and lugged it up into the barn with the rest of my crap. There it sits.

It was somehow clear to me that if I did ever put any paint on this board, I would completely drown it in paint. *Too* much paint. I would overpower and weigh it down. This would help. This would help. To pour my bile out. In gouts of whatever. I would feel the relief of a drunk who has just vomited. (But I didn't raise a hand to it.)

Valéry: "Physicists teach us that in a furnace brought to incandescence, if our eye could subsist, it would see—nothing. No luminous inequality remains and distinguishes the points of space. Formidable locked-up energy leads to invisibility, to insensible equality. Now, an equality of this kind is nothing but disorder in its perfect state."

Hot today. I looked at the board again, and this time I thought I'd douse it with kerosene and watch it burn. I could burn it privately, way out in the back field, away from the road, and the house. I could do it at noon; the moment of peak swelter. Or in the middle of the night. This would be so dramatic. But again: only for me. Drama for this tragic narrative; drama for this diary. It's evening and I haven't eaten today at all. Interesting that starvation and self-immolation are common ways to give your life for a cause.

18.

"Anything new on the novel?"

"No."

"It will come."

(No, it won't.)

Today I piss on all books. I'm suddenly furious (progress). I'm seething. Anger: an actual feeling. Let other people read and write. Go fuck yourselves.

Today I finally removed all the art supplies from their packaging. Laid them out. They seemed foreign. I was looking at an alchemist's tool kit. "What's the alembic for?" Everything: weird. I stood there again like a total dummkopf. That was enough for the day.

19.

Estrangement—the critical remove it engenders. This is important for me creatively. I posit that it, like pain, is a necessary condition for my work. Another clichéd hypothesis. Which does not make it, again, perforce, untrue.

This morning I went back into the barn. Took the painter's tape and attached the large plastic tarp to the floor. The tape is bright blue. There is a big tub of gesso, which I pried open after a long struggle. There were various tubes of paint in basic colors. Shiny trowels of varying lengths. I screwed dreadlocks onto a mop handle. Riffled the brushes in my hand. The canvases—still an undefaceable white. White white white. I simply knew in my bones that if I managed to paint, I would fuck up, and do not know how a painter contends with bad material. Will I have the requisite patience and follow-through to overpaint? I am spoiled by years of undo.

Gesso, acrylic, pencil

Sharpie, spray paint on linen

Acrylic, pencil, spray paint

Mind locked on failure, I left and went back to the bed. That was all I could do today. A step, if a small one. I've been told many times: "Just do one thing today. That, in and of itself, is an accomplishment." Is it? I suppose it is. It's the only way. "One step at a time." Goals into pieces. Person into pieces, family into pieces, years, days, hours, minutes.

Kristeva: "Melancholia becomes the secret mainspring of a new rhetoric: what is involved . . . is to follow ill-being step by step, almost in a clinical fashion, without ever getting the better of it."

My dreams last night were bleached.

20.

Held two (big) bottles of black and white paint, one color in each hand. How did this come to be? Who put them there? Said, out loud, "Fuck it," and ejaculated their contents onto the board lying on the floor beneath me. Grabbed two of my shiny new trowels and started to spread and scrape. The board was sopping, and I was wet-crying. I mumbled to myself. Breathed heavily. An hour later, I was done. Or at least too tired for more.

"Know when to stop," my father used to say (about art). My father made (to my knowledge) two attempts on his own life. Living is exhausting. It's hard to know how much more of it I can stomach. I turned from the painting and left. I never even really looked at it.

Opposite: Acrylic, pen, ink, spray paint

Acrylic, pencil, oil stick, spray paint

I hear his words: "Know when to stop." When it came to any creative enterprise, my father provided me with a lot of fancy metaphysics but very little of practical value. Outdoor dinner at dusk. Friends are getting braver. The air is less hot. A breeze comes down from the hills. A friend has roasted a chicken. There is fresh bread. Someone brings a salad, as someone always does. The jollity puts me in a deeper funk. I'm seated next to B., an artist, and the widow of S., also an artist. I remind her of my dad's "know when to stop." She puts down her corn, laughs, and shakes her head. "These men, with their pronouncements!"

Today: everyone but me outside reading. The day was hot and the family are indolent. Oh, to feel indolent. I am in the bedroom, which opens onto the porch. The bed is not a great place for me. Being in it is shameful, and the shame abets the depression. But the bed does feel, of the options, one of the safest.

V. told me she has been in the barn. Has seen my new laboratory. R. too. K. asked what I'm doing in there. She wasn't surprised I was making something, as I'm *always* making *something*. But there is hope in the question as well.

I told T. that I wasn't reading anymore and he fought me on it; refused to believe it. "You? Of course you read! How can you not? You of all people!" I know some people think I'm being hyperbolic. Some (the writers and editors I know) get angry at me and believe this not-reading is a stance, a repudiation of them and their commitments. I am like a new divorcé among married friends. "Is it contagious?" I don't bother telling anyone that when I used to read books, small hairs would fall from their pages, because I used to read so compulsively, with such devotion, that I'd read

during my haircuts. My barber used to say, every time, as if it were the strangest thing in the world: "Always reading!" Yet love affairs end. They end, don't they? Someone just moves on. If there isn't enough love left. Though sometimes love affairs end because there is a surfeit of love. Love is (or can be) incompatible with tranquility. There are loves one is not strong enough to bear.

I worked in the book industry. I've read professionally. After a while, all contemporary literary fiction—what people think of as "good" fiction—became, for me, a single book. A massive grimoire. It had a decent plot, well-defined characters, psycho-emotional stakes, finely observed moments, "luminous" prose, but it reinforced, unconsciously, reflexively, commonplace ontological and epistemological sureties; did not lift a finger to upend or interrogate a single one of them. No effort given to see the world anew. No sense that life may not be (merely) a stage upon which people *feel stuff about stuff.* Feel stuff about lovers, a landscape, friends, colleagues . . . about the way the light hits a vase. People feeling stuff about themselves, their parents, about the culture . . . This is a book that may wonder how a person should be, how a person should love, work, play, how a person might succeed or fail, but does not wonder what a person *is.* The tropes, but also the very language and structure of this book precludes such questions.

Yet this book is the book everyone loves? This book is the book all the critics adore, as it knows its place; doesn't overstep. (Modesty. Probity.) It is a genre, as rule bound as any, meaning it is a familiar book ("familiar"—a good term here, with its echo of "family," and the implication of a home; a place the spirit and geography of which is known and invariable).

The book believes life is like realism and realism is like life.

This is a bromide and an idiocy.

The book bores me to tears. I'd rather read a spreadsheet.

I am bitter.

Acrylic, acrylic pen, coffee on wood

Acrylic, acrylic pen, pencil

Acrylic, acrylic pen, pencil, coffee, whiskey, rainwater, dirt

21.

I can no longer nod my head in companionable acknowledgment of people. I've begun breaking the social contract. I can't perform what Tranströmer calls "the smile of accord."

I think these are called "phatic" forms of communication. I can't even manage the fucking gesture. Could I gesture onto the canvas? If so, I won't need to worry about how my gestures will be received.

I am dictating this entry into my phone, to be transcribed when light comes. I'm in the kitchen. It's 4:00 a.m. When I woke up just now, I was confused. It wasn't that I didn't know where I was but that I felt as if I was waking up in every bed I'd ever slept in. My life is passing before my eyes, but only the parts in which I was only liminally alive to begin with.

Today, I resolved to read again. I picked up a book to two, and the most I could muster was skimming. I was looking for corroborating quotes. Small bits here and there. Perhaps I will go back later and put some apt passages into this journal. Will I be bolstering my case? Providing evidence? Exhibits for the jury, expert witnesses, etc. (*Exhibit*-ionism.)

I go back to what I have already written and fix it. Editing is also a violence. I change my grammar, find better words, I strike things out. I have terrible thoughts. Dangerous thoughts.

To stop.

22.

The depressive recognizes the harm he inflicts on those who love him and, wanting to spare them, absents himself from their company. The solitude then reinforces the depression. Alone in the woods, while in the middle of today's hike, I felt as if the whole world has shrunk to the size of the stone in my throat. Maybe the stone is the size of the world. The diamond-hard core at the center of the stone is my father, his death wish, his death. I decided then to call this stone Pierre. And the thought that this might be clever made me physically shudder.

Wind clapping the shutters. I went out to see F. But as I got up to leave, I wanted to cry. This feeling of wanting to cry lasted throughout the drive, right up to his house, up to the knock on the door, and to the removal of my coat. F. made tea. The feeling of wanting to cry began to fade only when I picked up a pencil in his kitchen and started to draw. This is saying nothing profound about art and its power. Unless it is about its power to distract. We took a walk in the woods. Heavy mist. He pointed out the edible mushrooms. We were hunched over in our big coats. I said to him that we seemed like two spies making a covert drop. Subterfuge, secrets.

23.

Depression is a retreat. It is a diminishment. It is a secret. Depression is morbid and finds only dark nourishment; turning sickly fringed like F.'s mushrooms. They were piled on his counter. Some *could've* been poisonous.

My therapist once asked me, "Have you considered that your perpetual guilt might be harmful, not only to you but also to those you love; specifically, to those you feel guilty toward?" Those I feel guilty toward. The dead too?

When I left my father's sickbed for Paris, I thought a lot about Stephen Dedalus. I'd just read *Ulysses* in a college seminar. (I was of a certain age, intellectually ambitious, a Hibernophile . . .) Dedalus left his mother as I left my father. His mother was, like my father, dying. Dedalus left, like me, for Paris. He is plagued by her ghost throughout the remainder of the novel. The poem he attempted to write about her: "She comes, pale vampire, mouth to my mouth . . ." My mind is subject to similar refrains. The phrase "agenbite of inwit"—also from *Ulysses*—SD's earworm, is also my earworm. In Middle English this means, roughly, "the again-bite of consciousness turned inward." This is Dedalus's way of describing his guilt. It one of the best definitions of guilt I've ever heard.

Today, my guilt has fixed on a new subject: my cat Pickles. I miss her. She's not dead or anything, just elsewhere; back home. This, naturally, adds more guilt to the pile. I imagine my cat dying. It is unbearable. She's defenseless. Her sleepy, warm head was, weeks ago, in my hand; the weight of an apple.

24.

Getting out of bed. I roll over onto one side. This is the hardest thing I've ever done in my life. I prop myself up on my elbows. This is the hardest thing I've ever done in my life. I push myself back on my haunches. This is the hardest thing I've ever done in my life. Push up to a crouch. This is the hardest thing I've ever done in my life. Somehow, somehow, stand.

Will I go to the barn? I thought about it all day. The trip is a short walk. But too far for me.

25.

I don't mention my lacerating self-hatred to anyone. It is private. How would it serve me or anyone else to exhibit it? It would only be hurtful to those I love. Also disclosures are embarrassing. I think about the public confessions Wittgenstein made to his colleagues at Cambridge. Assembling everyone at his house, formally disclosing his failings. Those who were present remember this as spectacularly awkward. The disclosures further estranged the philosopher from the few friends who were still, at that point, able to abide his brooding.

I've heard that some people are good at keeping secrets. These secret-keeping people don't feel the temptation—let alone the compulsion—to disclose. Maybe they enjoy the thrill of withholding. I am heavy with the weight of secrets (drugs, dangerous thoughts . . .), which reminded me today of chewing gum in class. You'd have to lodge it

Acrylic, oil, pencil

Acrylic, oil, pencil

in your cheek so the teacher wouldn't see. It would lose flavor and dry up. You'd kill for a glass of water. But you'd be stuck with it. Okay, as long as you didn't move your face and avoided gagging, no one would know. When class ended you would hurry to toss out the hard, dead stone (*Pierre*). It clanged into the trash can.

26.

My mother's illness is progressing. I am responsible for her care—there's no one helping me. I mean that no one in the family is helping, and few outside the family who aren't paid to do so (aides, the astounding aides). But the more I help, the guiltier I become for not always being present, and particularly guilty for being up here now—leaving my mother, alone in steady decline. I can't bear the way her voice has become almost silent, a whisper. Though I am even more guilty about holding my own life so cheaply. Where my death would leave her, and K., R., V., Pickles . . .

Guilty of this furtive diarism. But where else can all this knowledge—these feelings—go? When I think about letting on, letting people in on anything, I also think: Get over yourself. Where else but here can all this—these feelings—go?

Barthes thought that certain modern movements—intellectual, political, psychoanalytical—had discredited the idea of confession, and he claimed that the only justification for diaries was literary.

Me and my narrator. The diarist. A falsifier of sorts. No one can transcribe events in the moment they happen except a court stenographer. Reporters take notes, sketchy at best. All writing, of any type—no matter its truth claims—is distorted, compromised. The "I" of the moment is necessarily distinct from the "I" of the journal entry. (Destabilizing

authorship: what RB later, recanting, referred to as "structuralist excess.") Honestly who gives a shit about any of that—one of the two admonitions I was given when publishing my last novel was "don't talk about Roland Barthes." (And when someone at my publishing house asked how I would describe my novel to the press, I said, "It's about a boy who rides a bike, but it's really about language acquisition." They then said: "Don't mention that second thing." This was the second admonition.)

I once gave a tiny bit of a book in progress to D. Just the very beginning of it. He savaged my work. He said, "What I want to hear about is not all that *theory* and *philosophy*. What I want to hear about is you." He was quite peeved about it.

Above and opposite: Acrylic

27.

When I was young, I spent a lot of my time embedded in other families (there was a reason for this, though it wasn't clear to me at the time). Each of these families: its own country. Geography, rituals, smells, mores. I'd be part of one of these households for a while, until a subtle change on the wind, some indefinable shift (a welcome overstayed), and then it would be time to move on. And so I'd take my custom (charm? need?) elsewhere. For a long while I used to sleep over at T.'s. His house was large and beautiful. His mother (Swedish) would make us little pancakes. Smaller than American ones. Little, perfect. She was a philosopher, and around the time I was a fixture in their house she was working on various books. I didn't know this at the time. I was in my thirties by the time I would read one. I found this line: "We are all, in a sense, experts on secrecy . . . We know both the power it confers and the burden it imposes." (The two big books of hers were called *Secrets* and *Lies*.)

Secrets: yes, my narcotics. But for what it's worth, and in my defense (exhibit A for the defense): the pills are reserved for two occasions only: when I'm in the barn alone (meaning, when the family is away or otherwise occupied), and at night, when everyone else is asleep. This is because I am rationing my supply but more importantly because I don't want anyone to see me doped up. The family has, on occasion, unfortunately, been around when I was using, but I have good cover. For the kids, my strange behavior is a sign of insomniac fatigue, and with K. it is symptomatic of the depression itself; its exhausting effects. (It is also true that when I am *not* high and *merely* depressed, I am also foggy and distant.) Nevertheless, I am pretty sure that given an endless supply of these pills, and given the requisite privacy, I would be popping them straight through the day.

In the barn today I felt the slow creep of painkillers treacling through my blood. I lay down on the floor, warmed by a tight quartet of sunlit squares. My body liquefied. I'm not sure exactly how long I lay there, but at some point the squares had moved—become parallelograms. (There are pockets of time in various locations around the barn. In one corner is sluggish time. Frantic time in another. There is another bit of rapidity in the middle of the floor. In some places, time pulses. In some places: *no time*.) The walls creaked in the wind. I eased myself up. Threw a dart and hit a wall about four feet away from the board. Stood for some undefined period. Later I fell asleep on the toilet. I may have thrown up but don't remember, and the toilet was flushed. Saw a

Acrylic, interior latex paint

faint, white footprint on a broad floorboard. Just the instep, a sinuous body, its head a big toe. On my hands and knees with a sponge. Later I heard the car grind into the driveway. Remote voices. Someone calls my name. "I'll be out soon!" I say (hoping that I've shouted, but not sure), my breathing so slow I worry about the pauses between my words: "I'll . . . Be . . . Out . . . Soon . . ." No one comes in. Why would they? I'm *hard at work*.

By evening, when I'm not so sluggish, I come in to shower and get ready for dinner.

Morning. Crumbs. Empty vase. Stub of a Ticonderoga pencil. Dirty fork. Coffee ring.

Last night, as ever, I couldn't sleep. Earlier in the year, pre-pandemic, I thought the opioids would help. They did not, and still don't. They do, however, make those sleepless hours feel really, really good. I don't get the sweaty panics when I take them. Instead, I feel pleasantly . . . gone. I might notice myself smiling up at the ceiling. Notice this while simultaneously looking down from the ceiling. Waking up is always a nightmare.

Now, also to my credit (exhibit B), I actually told K. before the pandemic that I was trying this anti-insomniac "experiment." She was worried about it, of course. She wasn't alone in this. My therapist told me in no uncertain terms to stop. I did not.

Funny that depression would exacerbate my insomnia when depression feels so draining. The revelation is that fatigue and sleep can be mutually exclusive. Natural enemies.

28.

Today the pianist Igor Levit streamed a live performance of Erik Satie's *Vexations*. This piece comprises a single theme repeated, over and over again (840 times, to be precise). With each repetition, this theme bores a deeper hole in one's psyche. Sun shines down on the nothing new. *Vexations* is a piece about boredom, about the monochromatic, about despair. It is a difficult, bewildering, depressing piece. It is an amazing piece, of course, but I hate it. It is an exercise in obstinacy. It is dead and deadening. I find it difficult to listen to. Change is what makes music music.

Change is an inaccessible concept to the depressive. The life of the depressive is a round. Not an unendliche Melodie but "Row, Row, Row Your Boat."

I would like to say: if we don't believe in change, why go on at all. Why go on at all.

Peter, Peter, Peter . . .

29.

Squished through the grass. My white boat shoes, carbon copies of the ones my mother wore back when I was only as high as her hips (distinct memory of her walking me to kindergarten, which is not a memory of her but of those shoes, the hem of a dress, and the schoolyard fence I couldn't see over). My father wore workman's boots. A practical choice for him as an artist but also a statement of intent and identity. My sneakers are rimmed with damp.

Opened the door to the barn. So heavy from the rain. I put my back into it, and once opened, I left it like this in order to let the sun's warmth filter in. I looked away from the painting I'd made, just after getting a general impression. I took the unmolested mop and headed back to the house, because I'd broken a glass back there. As I cleaned, I had this line in my mind: "Art makes nothing happen."

This "looking away": it is (aside from a form of avoidance) a technique I consciously employ when designing or writing or learning a piece of music. I unfocus my eyes; just get the outline. This allows me to: (1) Concentrate on only the broad questions and forestall being drawn into minutiae. (2) Defamiliarize. Distance myself from what I've made, so as to see it for what it is, rather than what I assume it to be. When I was at conservatory, I was told by a teacher that the hardest thing for a pianist to learn is how to listen to himself playing (while playing). It's true. So now, I'll leave a work (a work I am writing or designing or composing) alone for a period—sometimes hours, sometimes days or weeks, sometimes years—in order to forget what it is I've done. Then, when I've thoroughly forgotten, I'll pick it up again, and see it not as I want it to be, but as it is.

But in this case, the general impression of the board was not informative in the slightest. Too vague; the glance too quick.

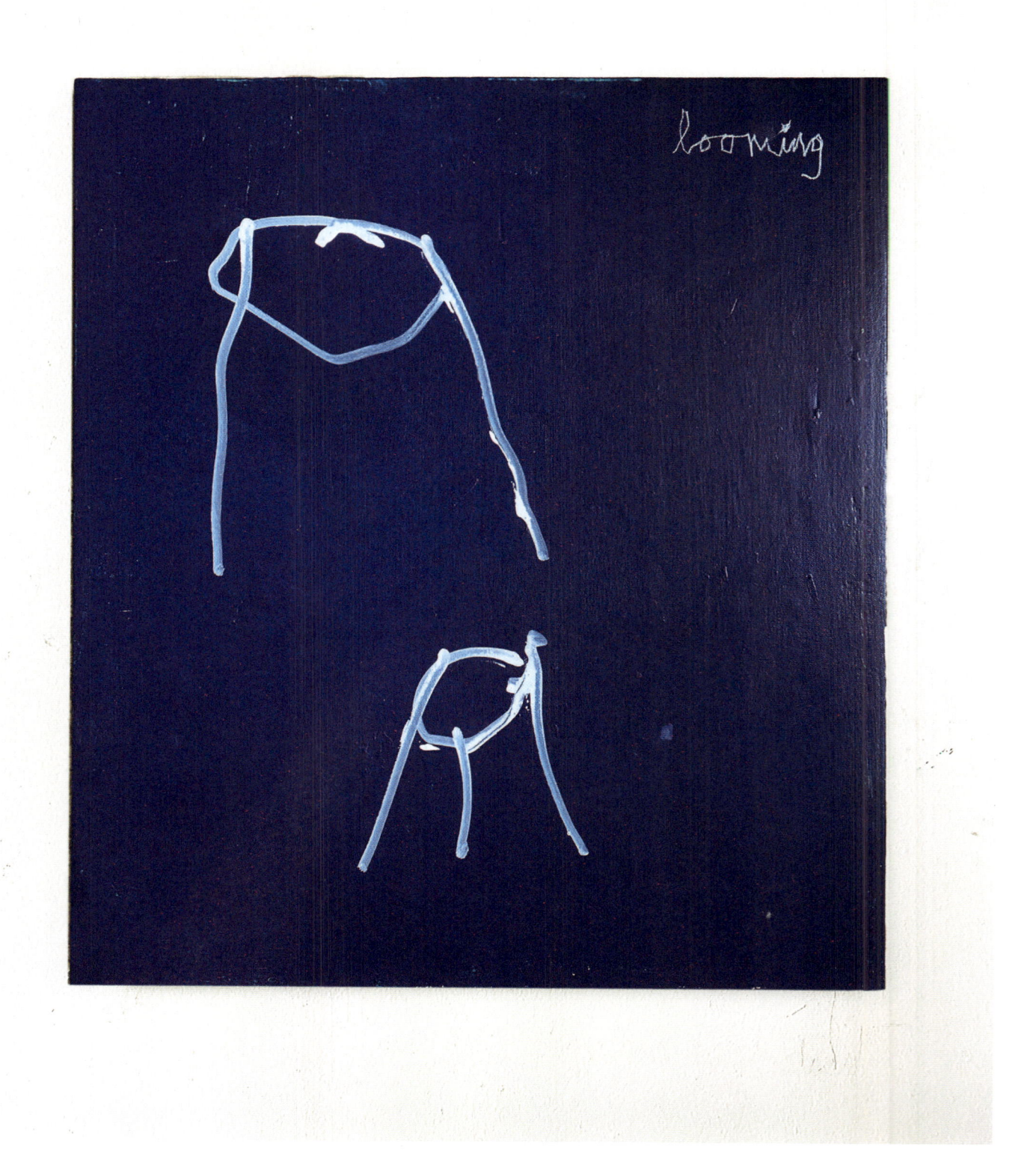

Above: Acrylic, acrylic pen, pencil
Opposite: Acrylic, Sharpie, pencil

30.

This morning, I did look closely. To see if art had made something happen.

The painting is a monstrosity, the sheer size of it. Hard to take in at once. I circled it cautiously, looking like a dog I saw yesterday below the eastern field.

A dilapidated board covered in black and white paint, standing high as my shoulders. I experienced it first as an object. Yet, it is not just an object. It has been worked on. Therefore, it is new. It has "happened." Something has.

I said out loud: "There it is."

Shy with it. We'd only just met.

I recognized that—below consciousness, in a dissociative state—I'd made this painting. Hypotheses had been developed, strategies plotted, implemented, rejected, proven, disproven. Yet, in some sense, I hadn't been there at all. Wherever it had come from, it wasn't from me.

Wait: I had felt something while painting. What I felt was movement.

31.

This painting was easy to make. Too easy to make for it to qualify as art (?).

No angel had to be wrestled and pinioned. This is remarkable. Writing is wrestling for me. Writing is combat. But with this painting, I was the subject of some subterranean process, some underground subduction or compression, tectonic shift or release of gasses or spring water. The painting was not worked on but thrust up from below. What I mean is that—while withholding judgement on its merits—I am able to say with certainty that painting it was a snap. (I was suffering, of course, but not because I was painting.)

My fundamental mistrust of ease.

32.

These entries are a mess. I am now spending more time fixing them than I am writing new ones.

Ex post facto: amend, spell-check, fact-check, rearrange, beautify (this is the strangest impulse, and the stupidest).

Meanwhile:

Anxiety ——>

<—— Guilt

——> Depression <——

I am still adding anecdotes here, many I only half-remember. And also adding quotes from books I only half-remember. Obviously, I brought no books up here. But I can search the internet.

Used a tiny pin to try to extricate a fallen pill from between two planks in the barn. What are such pins for? Tailoring? Why is it in a barn? I try to dig the pill out but cannot.

33.

Black and white. A feeling of the roiled self, sealed off from help; sealed off from reason. That abysmal too-much-ness of Valéry's. That indistinguishability. When my family looks at me, is this what they see? No, like everyone else, they just see a tired, sad man.

That common and generally agreed upon metaphor for writing—promulgated in writing classes, workshops, books on creativity—is that it is akin to sculpture. The writer takes a large chunk of raw material (free association, automatic writing . . . words, words, just get the words down) and chisels away at it until it finds a form. This metaphor is fine. But when I begin to write, I feel less like I am encountering a solid surface than an atmosphere—gaseous, perhaps noxious, and the size of all the air in the sky. This is how I feel writing this now. (Again, maybe I write more about Dad instead.)

The resistance of the wood, the viscosity of the paint. My body in motion. Muscles activated. Warmth gathering under my tee, ripples of the wooden barn floor on bare feet. I heard music coming from the old radio. The yeasty smell of the sawdust in the woodpile below. A medium in which there is road to meet the rubber. Where one does not need to engage the ether, as one does in music or prose.

Painting is an encounter with *things*.

34.

This morning I looked at the painting. The "painting," as I think of it. I thought: It's shit. And then I thought: It's amazing. Then: It's shit again. Who knows/cares. Depression has meant a loss of discernment (and ambition). The important thing about this painting is that it is black and white.

This narrow spectrum is a depressive's colors. No. Depression is colorless. Is my painting colorless? Pure surface? To me, that "zero," that blankness, would entail a lack of affect and would resist interpretation. It would elicit nothing. (Painting degree zero.)

My father's favorite artist was the sculptor David Smith. After Dad's death I inherited (managed to procure) his old, paperback monograph of Smith's work. Smith: "Black: is it a solid wall or is it space, is it paint, a man, a father . . ."

35.

Dry weep in barn today. The dry ones are bad. Worse than wet. Begged the tears to come. My tearless convulsions are constant, involuntary, and like a bad case of hiccups, each spasm makes the next one worse. My upper face is a dam, and the tension building behind it is immense. As I lie down in my bed at night I feel like my sockets are crumbling.

I'd empty the entire, urgent river if I could. But for those who might drown.

36.

Remembering: My parents' bedroom seemed huge. They were downstairs. It was risky. Moreover, it was wrong. Not a trespass exactly, yet still a crossing over. Powder-blue nightgown on the back of the door. A white ruffle at the bottom, which reminded me of a jellyfish (like the one I had seen on a vacation we took to a place called, wonderfully, Peter's Island). Deeper in: Books. Lots of them. On the bedside table: Small orange bottles. Blue pills. White pills. I wondered what they tasted like. I wanted to try one (but that's for later). Let's go to the bureau. The topmost drawer partially open. In one corner, shoved in beside the socks, was a horror. An animal. Flat. Darkly hairy like a dog. I could see a white mesh poking out from its underside. I left the room. One or two years later, I went to their room again to say I was staying over at a friend's house. My father was moving rapidly toward their bathroom. His hair was wrong. I could see that part of his head—top or side, I can't remember—was shiny and bare. My mother shut the door.

(My father, I now know, suffered a grand mal seizure on Peter's Island.)

37.

Maurice Blanchot: "The interruption of the incessant: this is the distinguishing characteristic of fragmentary writing."

I'm so, so tired.

A belief I've held since childhood has fallen away: that the world owes me happiness. That it was just waiting for me to collect on it. I believe now that happiness is loaned, and it is life that comes to collect.

38.

As an atheist, there are some religious rituals I wish I could take part in. Prayer, for instance, or singing songs with other people. I also used to envy those who could make a formal act of contrition. I loved the idea of confessional—a societally sanctioned, sacred, *private* spot where one could unburden oneself. Religious confessions take place in a dark box. Transgressions are shameful but, again, so are confessions (Wittgenstein). As I write this, I think that if someone were to walk in on me confessing, I'd give them a look like Pickles gives me when I see her in the litter box.

(I would also like to be a monk. An ancient scribe, copying holy language without particular attention paid to its meaning. Sacred scrivening.)

Acrylic, acrylic pen

Acrylic, acrylic pen

39.

When I got back to the barn, I started painting something new (!).

Painting, I thought: "like a dissident." I think what I meant was I felt driven, compelled, to paint, at the risk of severe punishment. In dread. I am in a state of dread but I have nothing to fear. The dread has no cause. Where's the firing squad? If only things were so definitive. Shostakovich was a dissident or a toady; hard to say. Or alternating between one and the other. What we know for sure is that he was always waiting, terrified of the nighttime knock or the phone call. Can't think of more depressive music than his. Also beautiful and ingenious music. His swollen, spectacled schoolboy face. His happiness too: the picture of him at the Spartak game or that smile of his, holding that pig. Maybe having something real to fear is preferable to the alternative? (Maybe not for the pig.)

I cannot remember the last time I smiled like that, felt such joy.

Somewhat predictably, I have now dabbled, I guess, in suprematism/constructivism. I make two paintings in that style. Both on yellow backgrounds. The yellow the old comrades used. Yellow with a touch of red, and a little bit of black.

40.

I have a few paintings now. Enough to say that I have painted some paintings. Maybe I'll stop

Joyless. No skin today. None. But amazingly, I finished yet another work.

41.

Inaugurating a new dispensation, I name a painting. I call it *Fyre, Fyre*, after the sixteenth-century madrigal. I took a music theory class as a teenager with an eccentric English composer. He was the son of an extremely famous poet, who treated him terribly. His father's nickname for him was "It." (Can you imagine?) He and his father had a long estrangement, lasting until his father's death. We, the four of us boys in his class, had to sing this madrigal.

Acrylic, pencil, dirt, rainwater

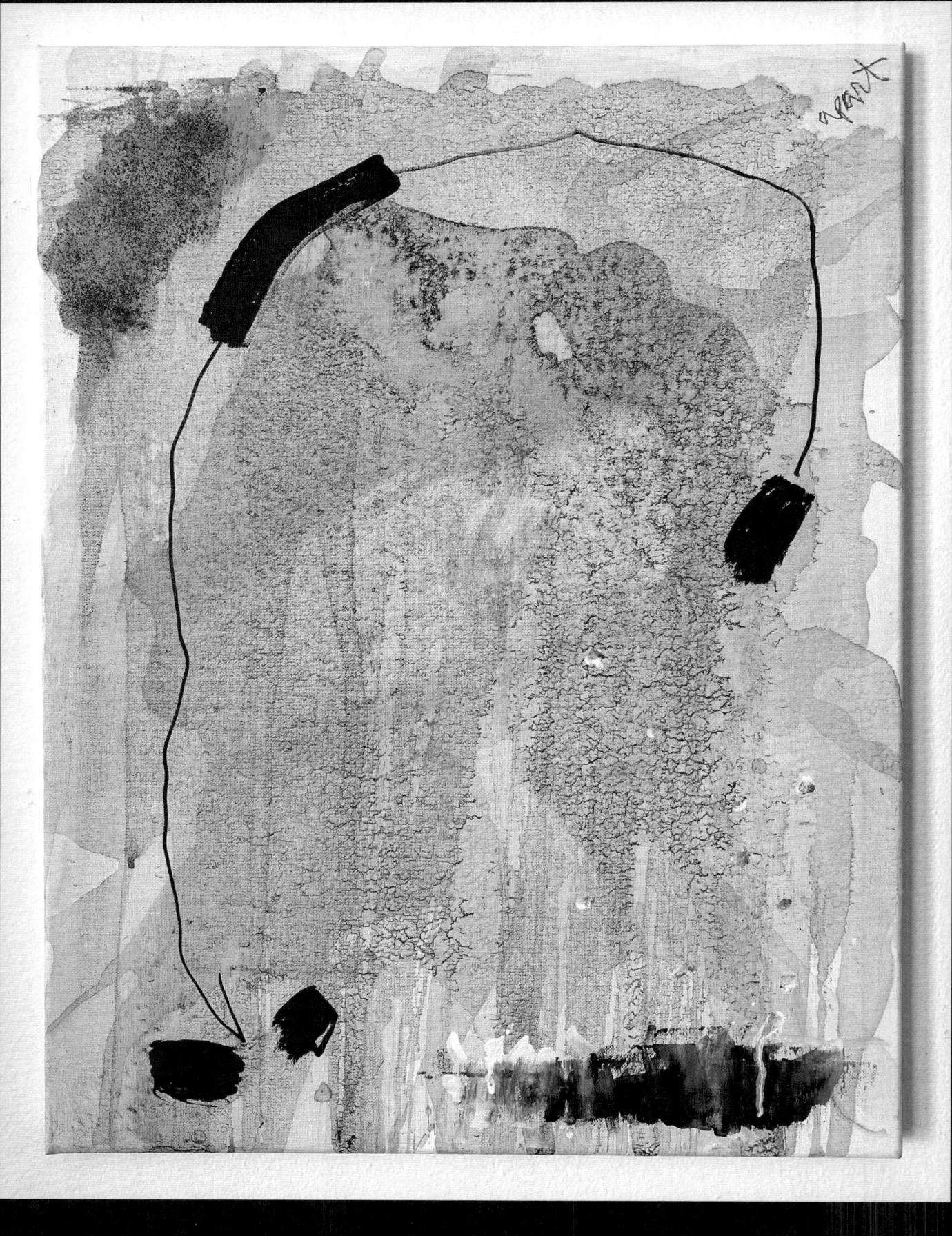

Acrylic, acrylic pen, Sharpie, dirt, rainwater, coffee

Acrylic, pencil, whiskey

Acrylic

Fyre, fyre, my hart! / Fa la la la. / O help, alas, o help! Ay me! / I sit and cry me / And call for help, alas /

but none comes ny me! / Fa la la la. / O, I burne mee, alas! / Fa la la la. / I burne, alas, I burne! Aye mee! /

Will none come quench mee? / O cast, cast water on, / alas, and drench mee! / Fa la la la.

("I burn me.")

In the car, I sang it in a monotone: "Fa la la la . . ." Remembered that Lucky Jim is press-ganged into singing this madrigal at a faculty gathering. I'm singing it like a dirge, and I'm driving, taking a route that runs through a forest that leans in close to the road. Drove slowly because of the ruts. The woods suddenly opened out, and I passed a small colonial. A family out on their front lawn. Crawled past, the woman, man, and their son all waved at me, slowly, in sync, like grass in wind. This made me think of David Lynch, his films, which also have a depressive feel and logic. That worm, beneath that perfect lawn.

42.

Desperate, lonely walk. Deeper in than normal. No one for miles. A tenuous little track. I saw yet another camouflaged hunter's blind off in a crowd of maples. Collapsed though. No footprints. Later I climbed some rocks. I kept startling birds out of trees. There was one huge, druidic stone I found oppressive. This kind of stone is called (F. told me) a "glacial erratic."

What a fucking terrible Thoreauvian moment. Trudged forward, my feet soaked, my forehead stung from exertion. Followed a logging trail. Went up a long hill. The view from the top might be described as spectacular. And I knew that if I could remove the cataracts from my eyes, I would see the magic in this. Knowing that I cannot ushered me lower into darkness. Headed north until, without preamble, I hit pavement. Started the long hike back to the house. Completely carless, this stretch of rural road; without sound of any kind. No barking dogs, rider mowers, child shouts, burps of tricked-out pickups or the growl of trucks bearing the gravel that seems a ubiquitous if mysterious ingredient of life out here. Then, I heard something. I'd been talking to myself. Actually, I had been berating myself out loud. ("You fucking piece of shit," etc.) Back at the house, pulling off my boots, told K.; recreated what I'd heard. She was shocked. Shocked at the content, the tone, and the intensity of this abuse. She said "I've never heard you talk like that. To anyone. Ever."

"You are so gentle," she added.

I've been talking to myself more, recently. I know. It's been getting worse with age. But this is different. Somewhere beneath consciousness this sadist has been hard at work. Screaming, but it comes through faintly, like a domestic disturbance next door. I'd been ignoring the muffled violence of it, but then the door opened a crack, only for a moment. There it was.

Back on the bathroom floor. Computer propped on my legs. Intense umami of sweat under my nose. "You must have heard that disapproving voice coming out of someone else's mouth, perhaps when you were younger." My therapist is right. But I don't feel sad about it. I feel disappointed. My inner bully is a plagiarist.

8M Life Fucking Sucks

Acrylic, pencil

43.

V. is upset. About *her* life. I sit with her. I listen to her. Her fears. I am there. I comfort her.

Exculpatory evidence.

44.

I think of Dad as an incredibly loving man. Large-hearted. And he was.

He adopted people. There was, for example, the moppy-haired Irishman who had been contracted to work on our house, who was an exemplar of a particular type Dad gravitated toward: what you might call the "working man," but whom my dad referred to in Yiddish as Chaim Yankel. My father nattered relentlessly with cab drivers, firefighters, construction foremen, cops, electricians, garbagemen, bus drivers, plumbers . . . He helped a refugee Cambodian family settle in Boston ("boat people," as they were called back then). He was generous. He was also animated by ideas: would debate just about anything with just about anyone. For instance the Jehovah's Witnesses whom he would, against all reason, invite into our living room for theological debates, much in the way he used to pick up hitchhikers and pull their life stories from them. He was extravagant with this sudden, chaotic love. The warm, enveloping, overpowering intimacy of it. The big smile, the goodnight lip kiss. The huge promises. We were moving to the country, and L. and I would be homeschooled. There was that house he would build for his parents, the model of which ended up hanging on a wall, the small structure perpendicular to the floor, his assurances of a happier life relegated to a work of art. (Also we were definitely going on a trip, he and I, just the two of us, one we never went on, *boohoo*, but which we were always in the act of preparing for.) The hearty laughter. My favorite memories of him comprise me reading while he worked on something, him not focused on me but loving me sidelong. The alternative, being the sole object of his attention, could be too much. And there was sometimes a price paid. Aftermaths. Criticisms. The implacable judgements. And Lord, he had a fucking temper

on him. In my thirties, after his death, I thought all that rage was due to all the corticosteroids and barbiturates he took. The tumor's incursions. Maybe that's the answer. I still waffle on the topic. Where did they come from, the storms? All of the above? Was this an intrinsic aspect of his personality? The wild ups and downs? I couldn't figure this out, it was never explained, and the topic was off-limits. Silence, always the silence. I spoke to my mother about this recently. I asked her about the source of his mood swings. She wasn't sure about their source either but thought: "Along with all his good qualities, he was also just like that. That is just the way he was."

My therapist has said she suspects the same. That his anger and exuberance weren't as much symptoms of his illness as much as him being "just the way he was." I take this to mean that he (being "just the way he was") suffered from what I (being "just the way I am") suffer from now.

45.

Woke up this morning in a panic, in the middle of a bad story. I pulled the covers up to my nose and considered never getting up again. "No one can make me," I thought. I also thought: no one can *get* me in here. Stayed like that for an hour, suffering very badly. Finally, I did get up but only to pull the diary from its hiding place and write this. The writing, maybe, is helping something move through me—lubricating my joints just enough that I can now move a little. Is this keeping me alive? When I began, I thought these

unearthed thoughts and feelings would deliver me from agony. Now I know that they won't. But the writing helps. The act of it. It is not that writing is a way for me to weave the fragmented world back together, though that may be part of it. The main thing is more rudimentary than this. The act—one letter, one word, then the next—somehow tricks my brain into feeling that I can do the same with my feet. My arms. My lungs. My mouth. Or maybe it is just a question of keeping busy.

I went to the kitchen. It was empty, but there was a pot of coffee, not exactly hot but not cold either. It reminded me of those supplies that rangers leave in cabins for stranded hikers. Potable water, dried food, etc. I went to the cupboard and reached for the first mug I saw, turning back toward the pot as I grabbed its handle. But the mug didn't move. I was jerked back toward it, comically. It was stuck. I pulled harder, once, twice, until it finally came free with a crack, taking a shard of wood away with it.

46.

Though I named that last painting, a benefit of painting is that you never really have to call anything anything. A painting can be, if the artist so desires, nothing more than what it looks like. Its optical facts.

No words necessary.

Still, my desire to name and transcribe—to dig into life and reproduce what I've encountered—is returning. Just

Acrylic, pen, pencil, coffee, dirt

Acrylic, pencil, coffee on board

a stirring of this urge. But god, another book? What if? What if I wrote a "fuck you" book? I am, today, like my first painting, full of piss and vinegar. (Better than dread.)

What if I merely painted the words "Fuck you" on a canvas? Stupid thought. Grandstanding. I could paint them and then erase them. No: smear them.

Smear them. Smear them.

47.

Does the painting help? Compensatory pourings, dryings, mixings and remixings, brushstrokes, scribblings, scrapings, etc. (and smearings)?

Here is another painting. How.

Brown, right now, is the color of my next canvas. It is the color of failure. I spread too many colors together and this was what I was left with. (I thought it would be black.)

Began a new painting today. Seventh . . . ninth? Sixth? Twelfth?

Turkeys are back.

4:30 a.m. K. smells smoke and wakes me. I can't smell it. I laugh. "If it's anything," I say, "it's coming from the fireplace down the road." She doesn't think so.

But she goes back to sleep. So do I. I love the smell of woodsmoke. The next morning when K. finally wakes, I am at the stove making coffee. She comes in and holds out her phone for me to see. There's been a huge fire in the next town over, miles away. "I have a great nose for fires," she says.

48.

Smear them.

"Smear them." I'm lower than low. But I've now developed a technique.

I paint words. I paint words and then destroy them. Smear them with trowels. Render them illegible. I know what these words are ("say") but no one else does. My paintings keep secrets. The viewer won't know these words *even exist*.

Or, they will know, and feel frustrated not to know more.

This technique is a big discovery for me. It feels like this. A "big discovery." Big. Important. Does another artist do this? Probably. Surely. Either way, what I like here is that the technique allows for abstract expressionism as camouflage (secret exhibitionism). It provides a rationale for abstract expressionism, for doing abstract expressionism now, all these years after abstract expressionism has more or less exhausted itself. (Has it?) Abstract expressionism but cloak-and-dagger.

Acrylic

I paint two words, one above the other. "Self." "Harm." And then I smear each into a rough rectangle. I have made a Rothko. Oops.

Sure, but also this is a Rothko with a semantic layer. This seems, again, interesting. And obviously relevant to my current predicament. I cannot describe my pain, isolation, inaccessibility. Depression's biggest effect, in my experience, is to render the sufferer mute. No matter what one says, nothing can be said. No one can know you, access you through the normal channels. You are alien, cut off. Language completely impoverished. No, totally bankrupt.

"The limits of language are the limits of my world." —LW

Language does not only set the boundaries that determine what can be expressed; it sets the boundaries for what can be known.

49.

I want to tell K., about my depression, "I live in a cage on Mars."

My father eventually became aphasic. Things were so bad then, for so many reasons. But the loss of his voice was shattering.

50.

Today, more smearing. I still don't know how to paint. I can't paint, I can't draw . . . I become worried—given how many paintings I've made now—that some expertise might develop. That even my smears might become more professional. Still trying to Kaspar Hauser this bitch and come at it with total, deliberate ignorance.

I fear I am succeeding in making good art, having held off the expertise thus far. Irritatingly, because of this success (in maintaining visual illiteracy) I keep coming back to an almost contrary idea: that, given proper ignorance, anyone can make good art. With these paintings, products of my ineptitude, I am borrowing tools from a cultural commons—from a Montessori discovery model that includes color and shape, and line and composition, elements simple as children's blocks. I've pulled my tools from classroom supplies, plopped myself down on the carpet, and used them in the limited ways they in which they can be used. Also, sadly, I suspect that I am borrowing from another cultural commons: the work of other artists. It is not that I am copying. I know so little about fine art, its history, practice, theory . . . I couldn't copy anything if I wanted to. But maybe I have osmosed some canonical work. (Or maybe I am some kind of degraded folk artist; without even the unique perspective intrinsic to being an actual outsider.)

Roland Barthes's final book is a book on photography that is actually a eulogy for his mother. He had this to say about photography: "Usually the amateur is defined as an immature state of the artist: someone who cannot—or will not—achieve the mastery of a profession. But . . . it is the amateur, on the contrary, who is the assumption of the professional: for it is he who stands closer to the *noeme* . . ."

51.

Sometimes people ask about my process: they wish to know how my books or designs were made, as well as how I felt while making them. In this way, they are making an implicit claim that the artist's experience of art-making is somehow significant. This always feels to me like a parochialism. I'm writing about process here, sure, but not because I think my procedures or experiences are in any way important. Who gives a shit what anyone's process is? Only the art matters. The finished article. The art. The art. Not what the artist thinks or feels. What matters is what he says in it; through it. And how he says it. How well he says it. If what is said can be understood.

If someone is interested in an artist's personal growth, they should read his fucking diary.

Acrylic, mud, rainwater, whiskey, coffee, coffee grounds, olive oil

52.

Today, I put on my big-boy pants and told more friends about my bad state (on Zoom; easier in pixels). They looked at me with such compassion and concern that I instantly regretted telling them. Conversely, one person visibly recoiled. He was clearly worried about whatever caretaking he might have to administer (I didn't tell him that I have far too much pride to accept any). Two other friends tried to push books about depression on me. "I don't read anymore, sorry." But also, I know some of these books already. Memoirs, natural histories, clinical literature . . . In one text, a famous one, a reasonably recent one, I read the expression "my madness" in the very first chapter. I mean, please. I would never use such a word. What am I, a hysteric? Anyway, I attempt to approach my predicament as I approach the paintings. Free from knowledge.

53.

My friend tells me to breathe. This is the most common advice I've been given since the onset of my depressions. "Count your breaths and slow them down." The problem here is: when I become conscious of my breath, I become anxious about my breath. So rather than slow down, my breaths accelerate. I become even more anxious. Also, as I count—as the number of my breaths gets higher—I worry I will miss one. The breaths will ping in my mind like a heart monitor. I will wish for a flatline. One infinitely long exhale. Think how quiet things would be after.

I have worry beads. I am fingering them more now. I wear one set on both wrists and I look ridiculous; a poser monk, a surfer, a hipster doofus. I hope they will help with the panic. I touch each bead, moving the bracelet clockwise. Unfortunately, I have begun to double-fist them, one set of beads in each hand, speeding through rotations until they are whirling like tires. Tiny clacks. I can't tell the anxiety from the sound and movement. I was in the frozen food aisle of the supermarket yesterday. Hands in my pockets, worrying my beads. A woman looked at me with disgust. My undulating pockets. She thought I was masturbating.

Acrylic, spray paint, pencil, coffee, olive oil

Acrylic, pencil on Sheetrock

More painting. My phone isn't here in the barn. I leave it back at the house. I am unreachable. The heart of each painting is too.

Broke a brush while painting today. Snapped the handle clean in half.

54.

Lines:

Perfect lines. Euclidean. Digital vectors—curves with Bezier points. Pencils pressed against rulers, picture frames, the spines of books . . . which will come out straightish, but there is always the telltale wobble, the hitch of seismic or cardiac irregularity. Then there is the free hand of my paintings. My left-handed lines.

Back to Michaels for more: white, black, red, gold.

A "good" line in painting or drawing seems to depend on either (1) deep focus and meticulous planning or (2) a pandemonious state of distraction. This second type of line is my line. Literally mine, in that no one else could have made a particular line I make (and yet it will have been made entirely without my proctoring and oversight).

Again—I cannot paint life from life. I cannot mimic what I see. But I can visually record the world in other ways. A figure stands alone on a yellow field. Massed against him: black. Me; the wheat; the woods? Sure, but to the viewer (the only person who matters in this

equation) there are only latitudes and longitudes, color, shape, composition . . . weight . . . signature . . .

Shit, a signature.

55.

A signature.

A signature in this context (painting) authorizes, identifies, sure. But it is also a component of a visual composition. So: How shall I sign? What will this choice (form, color) signify? A mark that works alongside other marks.

I decide on two versions.

My full name, scrawled in a wild cursive.

Another that consists of only my initials the initials of darkening day.

Acrylic, oil, pencil

56.

Hot again and I'm wearing fuck-all. There's a bright, new painting (and another illegible piece of writing). I think how unusual it is that I've made a series (unplanned, but still). I am surprised because I dislike artistic consistency. Maybe because I am unable to foster any. But where in life is there such unity? As opposed to divergence, friction, plasticity. I want to propose a matrix of possible forces. Provisional concepts, molten, shifty, sly, blurry, fragile, hesitant; notional, conditional, moving in and out of states of becoming and unbecoming, alternatively in complement and contradiction to one another. An art that is inherently fragmentary (Barthes, diaries, etc.).

Back at it. I simply can't stop myself. No one can say—despite this hell—that I am not productive. Another day, another painting. I like this new one. Decide I do not fucking care if anyone else ever will. And in any case they certainly will not be able to "read" it.

If my father hadn't developed aphasia, would he have told me more? I think not; I think he would've told me less. Whereas the aphasia spoke volumes.

Up to how many works now? I'm not taking the trouble to track them. Three stacks. I got three stacks.

I am painting like an injured athlete, limping through terrible pain. A particular mark might distract me, occupy my attention, but then the abyss opens up again. As it always does.

One of my favorite sentences in literature; from *Pnin*: "The accumulation of consecutive rooms in his memory now resembled those displays of grouped elbow chairs on show, and beds, and lamps, and inglenooks which, ignoring all space-time distinctions, commingle in the soft light of a furniture store beyond which it snows, and the dusk deepens, and nobody really loves anybody." That movement from the particular/personal to the despairing, almost dissociative universal . . . that movement—and the speed and cadence with which Nabokov expresses it—is one the depressive is familiar with.

Another artwork. I call this one (in my head) *Who Will Run the Clown Hospital*. Tried to tease out the name's significance. (I think, when I have painted enough of them, I'll go back, erase the names, and simply add numbers. Enough already.)

This new work is chaotic, slashed with red arcs, punctuated by black drips. These were originally words of course, as with the others, and then the trowels again. I kept turning the painting to see what would be right side up. Turned it one way and menacing clowns emerged. Honkable noses peeking through the havoc. Again I felt as though I'd made a self-portrait because I had driven to the nearest hospital a few days ago, just to see how long it took to get there.

Intrusive thoughts. I have started to imagine all the places I might die. Hospitals. Hospices. Subways. Forests. Malls, on a plane, at work, in my bed or in this bathroom here, or in the woods, etc.

Bad bad bad bad.

("Get *over* yourself.")

Today, mumbling with my brushes.

57.

Something entirely new now; with this work, here.
Inaugurating something. I have been buying the cheap
canvases as ever, but with this one I pulled all the staples
out, flipped the cloth so the uncoated side was face
up, then re-stapled it to the frame. I did not prime or
varnish the canvas. No protection of any kind. Instead,
I roughed it the fuck up. Savagely beat it, dragged
it through the mud (literally). Splattered it with the
whiskey I have been abusing. I did this to other canvases
as well. I left the new ones out behind the barn in the
rain last night. Weathered them. Now I stack them
without care. The corner of one jabs into another, each
painting making divots in the surface of the one below
it. They have been subjected to serious abuse. It makes
sense why this should happen. Why I do this.

More whiskey on the paintings. More and more. The
stains are beautiful. And this wanton expenditure of
alcohol means I'm drinking less of it, as I have less
to drink. The paintings are drinking for me. (A book
about people who can be hired by alcoholics to drink
for them—drink on their behalf—debase themselves

so their clients won't have to. Book about professional
abasement. Like Kafka's story. A book about
professional mourners. People paid to be abject. Forms
of hunger artistry. One book called *Drinkers*, the other
called *Weepers*.)

For twenty years—my midtwenties until the onset
of the depressions—I was a lightweight. But I drank
myself silly when I was in high school. I remember
many nights when me and M. would lurk under the
Queensboro Bridge. He'd be tripping balls, I'd polish
off a fifth by myself, sometimes starting in on another
bottle afterward. M. went harder drug-wise than
anyone I've ever known, but he told me recently that
he'd never seen anyone drink like I used to. We went
to London that year on a whim, because an airline
was offering cheap tickets. We stayed in a hostel. I
remember that we did this, but I don't remember any
details of the trip itself. I experienced a weeklong
blackout. (Did I urinate on the Royal Albert Hall? I
think that happened.)

And then more in college. I'd always chalked up those
old boozed-up periods to simply "being young." But
there's drinking and then there's frequent blackout
drinking. After school, after Dad died, I stopped. Glass
of wine with dinner. I didn't really drink again until
the depressions began. And with the depressions now, I
only really drink in private, which is of course the most
perilous way to drink.

These beaten-up paintings: I use little to no paint on
them. These works are less paintings than drawings
now. Most of the paint I did apply I've subsequently

washed off (unevenly) so the paintings are now peeling. I make new marks now with acrylic pens. I bought a few of these pens with the rest of the supplies and completely forgot about them. Only when I was cleaning up the trowels and paints and tarps did I find them inside a bucket.

There is even more of the feeling of chaos now, the sense of an uncontrolled, reckless hand at work. The world's reckless hand.

Surprisingly, today's painting resolved itself into something I like. I like quite a bit, actually.

And now—days on—I still like it. I no longer see the scars or think of the traumas it has endured.

This finished work is struggling between two languages: shapes and letters (knowing they are more or less the same thing, optically).

This one is square, pink and white. Reminds me of Good & Plenty. Nostalgia. I remember the corner store where I used to gorge myself as a kid. I suddenly can see the colors of every snack on those shelves. The lemon pies, the chocolate pound cakes, the Butterfingers and Snickers, orange Fantas, Dr Peppers, pork rinds, Hostess CupCakes, Twinkies, Pixy Stix, Little Debbies, Bubble Yum, watermelon Hubba Bubba, whatever that gum was that gooshed in your mouth . . . (What a miracle I am not diabetic.) I painted the words "Good 'n Plenty," pink and white, pink and white . . . the feeling of goodness and plenitude unimaginable to me now. I then smeared them with my eyes closed and with my left (nondominant) hand. I had spun myself around first. Still deranging my senses and disabling any expertise I

may have or may be acquiring. Eliminate anything that makes the painting "mine." The art is better without me in it. Death of the artist. Death of the author. Death of the designer, the musician, the husband, father, son.

Terrible. Art isn't calling to me, I don't want to paint. Not even art can do anything here; art, my last line of defense. Faced with the unmanageable as a child, I refashioned the world. Went up to my room and made dioramas, wrote little stories. Playacted. I'd sit down at my upright piano. Not to practice but just to work things out. I wonder what me "working things out" on the piano sounded like back then. If I could listen at the door. It would be interesting now to hear that tinny, exploratory music. It might break my heart.

But even when I'm not painting, I'm painting. Last night I painted while I slept. When I woke, I stood up and looked down at the brushwork in my tumbled sheets.

Acrylic, oil

Acrylic, crayon

Oil

58.

Z. comes to dinner for a pizza night. His Beethovenian shocks of unruly red hair turned white, his body limp. He drags his lower torso using a walker. He is just an upper body now. Still—far worse—his hands have gone numb, which is especially terrible as he is (was) a pianist. He was a music teacher of mine. And his concerts comprised my first real encounters with chamber music. The Ravel A Minor trio, the Archduke, the Dumky, the Schubert B-flat, the Shostakovich quintet, etc. I fell in love. This was the music I wanted to play. Music played with others—where I would not be alone in the spotlight (where the score could rest on the music stand and thus relieve me of the perils and agonies of memorization). But most importantly: communal art.

I remember one hot summer night in a practice room. I'm there with a violinist, a violist, and a cellist. I'm sixteen. We're reading the Brahms C Minor piano quartet. During the (almost embarrassingly) tender and confessional cello melody in the adagio, the cellist closes her eyes. I close my eyes. We are, suddenly, playing in the dark. Did everyone else close their eyes? If so, we would be as conjoined as people could ever possibly hope to be. More than in prayer, more than in sex. Conjoined in this immaterial territory we were building on the fly. No words.

Z.'s situation is grave. Mine must not be. His is so visible. Mine is perceptible only to those who are the closest of readers. And even they can easily mistake my condition for, say, moodiness. I think, watching Z. attempt to navigate the ground floor, that I feel even *less* than an upper torso. I am merely a head. No, a mind. A dark(ling) plain.

59.

It is probably obvious to everyone that the pain you inflict upon yourself can overwrite the pain that life inflicts on you.

So a long, tough run today; even longer and faster than normal. Chugged my way past the nearest habitation. Small firehouse, four old homes. Cemetery: the newer headstones in front, the ones that look like teeth—old and time-lumpened—in the rear. Not sure what makes it a "town." Yet it is a town, or so said an old iron sign, bearing its founding date and original population (minuscule). Leaving, I ran up a long hill, past sprawling farmland. It was hot. All the cows lying down. There was an old, collapsed building. Once a barn, perhaps. Its roof was on the ground, but more or less intact. There was a scrawny goat standing on its ridgeline like a weathervane. What was that goat doing on that roof? I hit dirt and kept going. My lungs burning. I could not feel anything else besides that lack of oxygen. I'd run until my lungs burst if it would keep the other thoughts at bay. I followed the road farther, into the woods, then an absolutely enormous dog came charging out at me, teeth bared. It stopped inches away, snarling. A thin old woman came out onto the porch of a nearby house and called to him. She shouted something, amazingly, that sounded like "painter." Then I thought she was screaming my name: "Payder!"

Then:

"Did he bite you?"

"No," I said.

Acrylic, pencil

"Bad Mater," she said.

Ran on, wondering why this lady—knowing that her dog is a biter—still had him untethered.

Mater: spoke to Mom. She has vomiting jags every month now. Down from ninety-five pounds to eighty-eight and still falling. It used to happen once every three months, then once every two months, now once a month. At this rate, in a year or so she will be eighty pounds. No shaking yet. But she's fallen hard a few times. Hit her face on the radiator. Her handwriting has become illegibly tiny. I got her an alert bracelet. She isn't using it, I think. She has a walker. But it seems like she isn't using it either. I am stern about it with her. We will need to look at assisted living maybe. Fuck.

Today a different route. Avoiding Mater. On the return leg, I saw a red-tailed hawk.

Birds of prey. Incarnations of the dead. Visitations from the beyond. During the year of Dad's death, I would see hawks everywhere. Looking for signs wherever I could find them. I listened for their *skree*s, and watched the skies.

Dream: Walking on a country lane with my family. My phone rings, and for some reason I desperately need to answer it. It feels imperative that I take the call out of earshot of my wife and kids, so I tear off down a road, phone pressed to my head. As I do this, I see that the branches overhead are just teeming with owls. Like an infestation. And each owl has, rather than feathers, a furry pelt. Specifically a tiger pelt.

60.

After an attempted suicide, my father entered a coma, which in turn landed him in the hospital, and subsequently (the timing is vague) he entered a rehabilitation center where he stayed for some time. I wasn't told what had happened. (Also, I didn't ask any questions.) At that point, I had known two people personally who had killed themselves. Both teenagers. One was a classmate, the other a woman I had dated for a brief time. The classmate (one of the four boys in my music theory class) shot himself at a target range. My ex had jumped from a building. Our friend group mourned. We worked through it in various ways but always together. School convened assemblies, discussion groups, vigils.

Acrylic

Acrylic

61.

I start dating the paintings, writing the date on them, but then decide to stop. Each moment I am living through is an eternity. Also there may be no future, no moment ahead for me in which I will look back and wonder, "When did I . . . ?"

Self-loathing solves so many problems. It drives all other accounts from the room.

I always like to have several projects going simultaneously when I'm working. That way when one project seems hopeless, I can find hope in another. (Until that project feels hopeless too, at which point I turn my attention back to the original project. Rinse, repeat.) Also moving back and forth between works allows me to see both works clearly and avoid the claustrophobia and myopia of a single endeavor. I've primed up some new canvases. We shall see.

I get to painting and immediately hate what I've done. I should be using thinner lines, instead of the big, sloppy strokes I've made with the trowel. If I did this, the painting would become more coherent, I think. Until now, I have resisted employing any conscious planning with these paintings. Everything can so easily become mechanical, rote. Should I think before committing? Put the brush down? Put the pad and pen down, close the piano lid? Take the time, as I usually do, to speculate? Conjecture is dangerous for me. Seeps out of art-making and into life. My curious and counterfactual-obsessed mind inflicts upon me a state of constant anxiety. I cannot seem to stick my mind to what actually is. Instead: *What if* C-sharp? *What if* blue? *What if* this sentence, here? Occasionally, conjecture leads me to wonder if

things might just change for the better. This is blind hope rather than speculation. Mostly I catastrophize.

Another new painting tries to speak. But there are things paintings cannot say, there are things words can't show.

62.

Not only do I have no skills as a painter; I use only the worst (cheapest) materials. The ones I took from the aisle between "appliqué" and "scrapbooking." I am now committed to keeping up this practice, this unfussyness. My eschewing "the good stuff"—whether in terms of materials, proficiency, or knowledge—may pay dividends. It may be a great boon. As a total dumbass, a dumbass with dumbass brushes, I am free to attack each canvas without stakes. Each of these canvases is an opportunity to do something rough, naïve, art(ist)less.

63.

Amateurism is working. Stupidity is working. I feel unconstrained.

Today a strange thing happened. I don't know what it is. But something shifted. A change in the barometer. A

Acrylic

Acrylic, Sharpie, pencil

change in altitude. My ears popped. I wished I knew the names of all the plants in the fields.

No painters know that I am painting. No gallerists, no critics. Barely anyone. I am totally free.

This is an unusual state of affairs—making art in private. I've found that the majority of my projects (the ones I've brought to completion) begin with a lie. One I often tell multiple people. Sometimes I tell it to everyone. The lie takes the form of: "I am currently working on _____." This statement is premature but locks me in. Puts me on the line. Once I've announced the project, people will start asking: "How is the new project going?" And I will not only be forced to answer but be shamed into actually finishing. (But also the utterance, even a private utterance, can be a necessary prelude to action.)

I am painting. I still don't know why. But just look at those completed works against the wall.

64.

Today I practically ran to the barn. I threw wide the huge door without effort, this time unbolting the back door as well, and the summer came in on both sides. I looked at my new canvas's surface and was tempted to write something, but on top of the painting. *Visible* words. I'll write them and leave them be. I'll communicate something. A semantic something. Is this impulse a sign of the depression ebbing? I painted a background; a solid color. Got a black acrylic marker and scrawled a lowercase *i*. After looking it over again

for about ten minutes, I added some blue paint. A sky, I thought. Mimesis? And then a smear of yellow: a ray of light. Added more letters. I was writing and painting simultaneously. Writing and painting, writing and painting. The letters became a single word, fractured. The *i* became the seventh letter in the word "Annunciation." Annunciation: one of the old subjects. The word in pieces, some of the letters were tiny or buried, but it was still possible to read them if you tried hard enough. The discourse pulverized but still coherent. An annunciation gone wrong. A denunciation?

"Je vois le langage."

Bright blue painting today. I smear the words again, but only because I've grown used to the technique. A blue I mix using three colors. I don't know how to mix paints, but the blue is perfect. I love it. The words, the marks I put on it are not morbid, not angry. The marks are a pale beige. These marks are sloppy, but not as hell-bent-crazy as in the first works. There is a pattern here too. The strokes, collectively, seem to form something. The first thing that comes into my mind is an ideogram. In other words, the painting wants to become legible. This is what I think, looking at it. It wants to speak. I set my blue painting on a plastic tarp, lean it against a beam to dry, slide open the barn's rear door, and sit on the steps in the light of late afternoon.

Back in the barn. The next one is bright red. Red. The red is simply astounding. And so, so surprising. Once when I was in college I went to bed with a beautiful brunette woman. When she pulled down her underwear, her pubic hair was bright red. "You're a redhead!" I said. She looked at me like "You blind idiot," and that is how I feel today, like that blind idiot. Red was there all along; me too dumbass to see it.

Marigolds. Black-eyed Susans.

Yarrow. Chicory.

I once had to sub in as an orchestration teacher for
night classes at Juilliard. I taught students instrumental
techniques. How a trombone moves through the overtone
series. What the open strings on cellos, violas, violins are,
how to write in B-flat for clarinets, etc. More importantly,
I taught them about instrumental color. What the sound-
color of muted French horn is. What the color of sul tasto
is. What happens when you double a contrabassoon
with a piccolo. I gave them examples from the masters.
Tchaikovsky's celeste. Stravinsky's harmonic glissandos
(possibly stolen from Ravel). Debussy's swells. Bartók's
percussion. The process of orchestration is the process of
coloring a musical work. And through coloring, changing
its emphases, and therefore its structure.

My father's colors were almost uniformly dark and
desaturated. Even his reds. Remembering these reds—as
I must, owning so few of them as I do, as they only live
in memory. (Where did so many of these works of his
go?) There is a collage on my mother's wall that features
the head of a shovel painted a red so dark and dull that
it is almost brown. I see a "vibrance" dial being turned
counterclockwise. Why did he turn this dial down? It
may be the case that the hues were determined merely
by the materials he used. Maybe it was that we lived
with his parents, who had barely survived the Shoah.
Or that he was so ill, and always drugged, or, again, that
he was already—even before the disease—chemically
imbalanced and desperate?

I was imagining—only last week—that if I were to be
suddenly diagnosed with a lethal illness, it would solve
many of my problems at a stroke.

Again, this mystery: the strangeness of my bright colors,
even in my darkest hours.

The next painting becomes purple. This painting feels
(I use, in my head, this particular word) "authentic."
I am not sure what I mean by this. Surely a painting
authenticates nothing. Except, perhaps, its own,
particular marks. (Which, of course, very well could
have been others.)

Dad in the blue painting—his relentless blue eyes. Alight
with joy or remorseless. How strong the symbolic order
is. It exerts a much stronger gravity than the facts in
front of you. The facts on the ground. To experience blue
with such force is disturbing. I think I will overpaint.
Trot out the gesso. Bye-bye.

I don't do this. Instead, I think about a new painting.

Acrylic, oil, acrylic pen

Acrylic, oil

Gesso, pencil, painter's tape, butcher paper

Acrylic, lipstick, pencil

65.

Tonight, my mind is alight and I am filled with love. Paternal, uxorious, fraternal, avuncular, civic, theological, erotic, ecological. All the loves. The night is abuzz with croaks and chirps. The wind is surging in the branches. It is simply wild out. The sky teems with stars. Alone on the porch, the night scent. Brisk, smoky air from the chimney, so . . . wholesome; I gulp it down.

Who could sleep through such a feast!

This morning something returned. I feel it still.

Ate everything in the fridge. Laughed. Cleared the plates and chucked R.'s shoulder. I drove V. into town to get that tuna sandwich she likes. Family life is this, a series of mundane routines, the procuring of a sandwich. I got the same one as her. It has apples and horseradish in it. The tangy sweetness.

How could I have possibly forgotten.

More painting.

Red-capped mushrooms. Sage. Lavender. Bit down too hard on a tooth, grimaced and laughed. Clouds above were troweled!

Don't celebrate. Sudden abundance.

Met F. for a beer and I got buzzed. Only buzzed, as I was driving. This new sense of responsibility. Didn't feel the need to extinguish myself. I asked him about his work, his family, I asked after the health of his dog. Life's okay, he said. I didn't begrudge him this, this contented "okay," and

Acrylic, pencil

my not begrudging was a wonderful surprise. We talked about art, as we always do. What qualifies as "good" art. How is good art made. What is it made of. Does art tell us about the world, or does it merely provide formal satisfactions. Who is art—good or otherwise—for? I tell him about a line T. gave me once: "Art should be from and to."

We left the topic, covered all the others. We solved the world's problems. At some point, he tilted his head and looked at me quizzically.

Alone on the back roads, I cranked the radio. In New Hampshire all the music is shit. I was deep in a Van Halen rock-block. Bellowing, I opened all the windows.

PAINTING 1

Opposite:

Acrylic
on plywood

66.

Peter, Peter, Peter, do you remember?

67.

Replete. I am an electron. Buzzy. Unbound. In two places at once. Three. Your best friend. I excel at my jobs (so many of them). Exceed my mandate. Ideas come a mile a minute. Connecting everything in unexpected ways. "You are a dynamo." "Do you ever sleep?" There's simply no stopping my forward momentum. I give a talk, two, three, ten. Write a novel. "Cool book," I think, more self-congratulatory than self-hating. Another. Design books too. I wear all the hats. Learn quickly. Act quickly on what I've learned. Fevers of productivity. I see patterns. I speak all your private languages. I meet you in your secret places. Endlessly curious. I look around and think, in general, people like me, enjoy my company. Successes. Money. A talk: I traveled with my family for it. The auditorium is huge and full. I had slides, though didn't need notes. Never need notes. Never prepare. The slides were enormous above my head on a screen. I'm talking too fast. I'm cracking jokes, slinging gossip. I realize at some point that I am swearing like a stevedore. I peer out to my kids in the audience, about twenty rows back. Something in me twangs. But it's too late to stop myself and, anyway, I do not want to. My irreverence goes over great; people are laughing, clapping. I ride the enthusiasm. After, after the signings, handshakes, my family is shy around me. I don't understand this shyness, and wrongly attribute

it to their having been overawed. Now I can only think of my children wondering where their father went. The degree to which I would've appeared, suddenly, a stranger to them.

They've seen me like this at parties, in the playground, at work, at home. This stranger: that's me. That is me also. My poor wife and kids.

Later someone reaches out to me to see if I'd be interested in giving yet another talk. A big talk. The big talk. The one in which the world's intractable problems are solved with a Sennheiser headset mic and a shameless degree of self-regard disguised as humility. Niche profession plus tech evangelism equals obvious solution to age-old quandary. Room-temperature cold fusion achieved through quilting. Housing crisis: mime, etc. I attend three of these talks at the organization's NYC office. Am sickened. The world has begun, by now, to darken once more. So under the circumstances what would my talk be on: "The world is a vale of tears?" I fade away, having succumbed to another full-blown depression. I'm never contacted again. Maybe in the end they decided they really didn't want me anyway. Maybe they never did?

In the bedlam of my mind there are many mansions, with a wide variety of lunatics living in each. Or perhaps just two?

Eating like an animal. Everything smells, feels, sounds, tastes good. Will miss my sleek, depressive's body. P. over for dinner, we laugh about our trip to Italy in '95.

No wonder I compulsively feel the need to dwell on what isn't. I have these two sides, one of which, at any given time, is completely absent.

Opposite: Acrylic, pencil, coffee, whiskey, rainwater

68.

Schumann created two characters he called Florestan and Eusebius. He named certain pieces after them (or, they are alter egos, heteronyms, like Pessoa's, meaning Schumann thought of them as authors of these pieces). Often he identified the score by their initials: F. or E.

To my knowledge, there's only one work by Schumann in which both characters are named together: both F. and E. It's the last bit of the *Davidsbündlertänze.* Two upper voices (soprano and alto). Dance partners; moving in and out of dissonance and consonance. This perfect pair, destined for each other. They've just met but: too late. Too late! They've met only at the close. Polyphony at last. They dance their way down the registers, the octaves, into deep shadow and then: poof. God, it's so beautiful.

Work birthday. Celebration with colleagues on Zoom. Few people know that the song "Happy Birthday" begins on its lowest note. Everyone begins too high. This means that by the high note, everyone is out of range and screeching.

Another shining morning. I made coffee for the family. Frothed the milk. The bread is soft and malty.

The fields were lacquered. A mobile of vultures hung in the sky, tapped by an invisible finger. Do I believe in God: could be, could be. Sage grass. Birch; maples. I wanted to paint all that but couldn't. Literally: I am untrained. Still, having begun to paint, I am more attuned to what I see. Specifically to surfaces. I have turned away from depths (life, degree zero?). I believe that this is a sign of robust well-being.

More paintings. I'm fucking fecund.

More writing of visible, if broken, words. Breaking them up until they are nothing but fragments (letters). The paintings are miscellanies. Wunderkammers. Knickknacks for the bricoleur.

The words that are visible here are the simplest ones. Ones that describe the most obvious formal arrangements in the compositions. "On," "under," "above," "through," "in." These words are wryly redundant. Just the atoms of language pointing to the world's own atomic units. (Ostension; St. Augustine.)

Then, I make a new painting with two shapes, one above the other. The word I write on the canvas is slightly more suggestive and nuanced than usual. I write "looming," rather than "above." Not sure why. I feel nothing looming. For a change.

"How was today?" K. asks, visibly not dreading the answer.

69.

I work at night under aluminum lamps that I've clamped to the beams. Occasionally moths will sacrifice themselves to the wet paint and, not sure if it will do any good, I pull them out, looking like newly minted butterflies.

I'm in Michaels. "Do you have a rewards card?" asks the elderly cashier in the red bib. Same woman, the same question every time. I always say no. In too much of a hurry to use the paints I've just bought. I can't even abide waiting for the double glass doors to swish open. I need to run to my car!

Slightly cooler out. Forest is still blue, green, brown, and purple but also yellow, and the evening sky is a Creamsicle.

70.

I've completely thrown in the towel with regard to my appearance. At the beginning of the pandemic, already in the throes of depression, I stopped shaving and cutting my hair. Still haven't. Crazy beard, and hair to my shoulders. A ragged-ass demon. I see that, unintentionally, I have become the very picture of a painter, of Dad. Painters look like they've been working, as in putting in "an honest day's work." Pleasing.

My new look and the cultural capital I like to imagine comes with it: my shirts are stained at the pits and all my clothes and exposed limbs are covered in paint and grime. Jesus, I reek.

Dad dyed his clothes. And I remember an apron he fashioned from raw leather. The skullcap he sewed. He wore ratty fedoras: removed the ribbon and feather, and pummeled the shit out of them until they were entirely reshaped.

Repurposings. An application of the idea that the artist treats everything as art (pretty trite idea, really). But with the hats at least, I now understand that he wore them to hide the effects of his disease. (The hats, or the furry monster in his drawer.)

Mourning the death of a loved one comprises a regular, disconnected, years-long (lifelong?) series of sudden realizations (mostly the realization that someone has died).

Up before everyone. Made coffee, went out to the porch and drank it. The sun slowly toasting my face. Large pad of paper, and pastels. "My first work on paper," I thought, ostentatiously. Turned on the radio. Remembered that noises on the porch carry to the bedrooms. K. and kids were asleep, and I didn't want to wake them. I turned the music off. Where did this particular (small, negligible) act of compassion come from? It was as mysterious to me as this efflorescence of—can I call it?—happiness and as inscrutable as my newfound art practice.

There is a Failed Painting
on the back of this one.

Acrylic

71.

R. and V. are also suffering. What a terrible father I have been; unable to summon the strength to help. The pandemic is hard on them. At an age of maximal liberty and agency, they have had their wings clipped. Now, by whatever species of miracle, I am present and compassionate, and I wish I could take their pain on, take it upon myself. Drink every single little drop of the soured milk, contaminated water, toxic sludge that comes their way. One or two or five or a hundred gallons. I imagine myself behind a table, in front of banks of cameras, all the poisoned chalices before me, Joey fucking Chestnut, a crowd cheering me on. Chug, chug, chug. These thoughts bring back an aftershock of the depression. I suddenly think of the line "Look at that scraggy tree,

Acrylic

look at the iron railings, the boulevard . . . and the ice is floating in the wine-bucket . . . Oh Gods, Oh Gods, give me poison, give me poison!" Mikhail Bulgakov breaking the fourth wall of his metafictional novel. Don't, I say out loud. Don't, I say, and think of other things.

Paint more. Words words words. Some hidden. Some are too basic or fundamental to possess real meaning (they communicate nothing). Now this is not an expression of despair but a motherfucking relief. A selfless act; I don't mean charitable, but without self.

On my way in the house, I peel off my T-shirt and pants. I arrive in the kitchen undressed and do the dishes. My hands get a scrub, and scabs of paint clog the drain. I like doing dishes. I'm the first to volunteer for the job. Not from altruism. Rather, it is a way to be left alone. And doing the dishes is a well-defined task. With dishes, the aim and results are clear. I thought this while drying. Doing the dishes does not propose anything.

I never have to wait long before knowing what my next project will be. Ideas just seem to find me. And so, whether or not the paintings will be artistically profitable, it feels natural now that the paintings happened. I feel that many more will follow.

72.

The most recent work is slapdash. In the best way.

I'm still painting left-handed. (And still, sometimes, drunk. Though less drunk. I've stopped with the Percs altogether.) My senses are less "deranged," yet I am still committed to disorder. I am artless. Artless! My diligence in maintaining my incompetence has paid off. I have said my final fuck-you to expertise. Amazing

I've decided to try transferring my paint—mixed with a cloudy, sperm-like medium—into plastic restaurant ketchup and mustard bottles. The nozzles are smaller, and this allows me more control. Squatting down, squeezing those bottles: it's like milking a cow.

Squirting words. Standing up, ignoring my stiff back.

Artless, artless, artless.

A while back, I was asked to provide a blurb for a book about the history of Rorschach tests. In order to do so, I learned a few things; for instance, the word "pareidolia" from the Greek "beyond images," refers to the human mind's tendency to find meaning in abstraction. Inkblots are diagnostic tools. Even though they don't appear to be meaningful, they are, of course. Meticulously made to elicit diagnosable responses. My inkblots serve no purpose but still may provide, for me, after the fact, diagnostic understanding.

I draw my eye away from these new shapes of mine (smears, not blots) and toward the gaps in between

them. Negative space. My father disliked negative space in art. "Always fill a composition."

More hawks in the sky. More sun, spilled onto the land. Belief in art, and the peculiar dream it dreams.

73.

Attacked this next painting violently, but this violence was a healthy, happy violence. A violence directed outward. Yea-saying, Nietzschean violence. Good. Good. So whom was I assaulting? I was, of course, sublimating. After some thought, I came to the conclusion that all that ferocity was now, specifically, directed at those who would judge me weak. Only a short time ago, I would have agreed with this bloc; their cruel assessment. But as of this writing, I am *sure* that the depressions I have suffered from and somehow manage to endure require a bravery many would not be able to muster.

I feel strong now. Of course no one feels quite as strong as when one has recovered from an illness.

Painting, the profession, seems fictitious. Painters can't exist, not really. They are like space cowboys, ghostbusters, tooth fairies, yeti wranglers. Colorless green ideas that sleep furiously. Who would call themselves a painter?

Not only am I working violently, but I seem to have made this new painting blood red. The corner of the barn is an abattoir. When the red layer (words; smeared)

Acrylic, acrylic marker, pencil

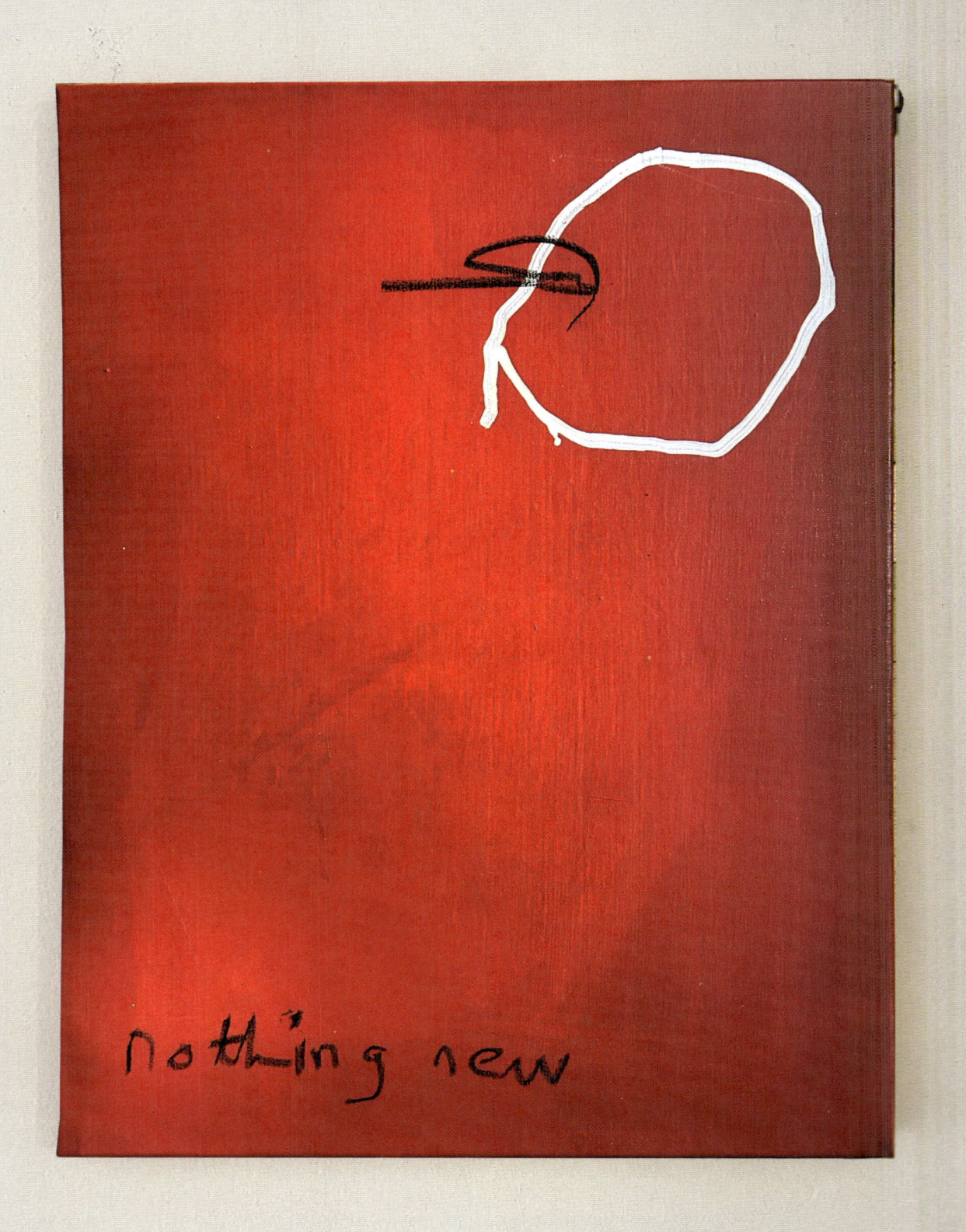

Acrylic, acrylic marker, pencil

was dry, I realized that the violence was more than I cared to disclose, and so I painted over it. A pale pink on top. The painting is now my body: pink, scarlet beneath. This painting, like the ones before it, like real bodies, is driven by secret organs.

So this pink hides the violence; or maybe, having expressed the violence, I feel pink (in the pink).

An excavation. Looking for a rich, pink seam. The seminal pink that led me here. A pink rife with association and indelible—if hazy—memory. I would reveal pink's private meanings, secret history, hidden erotics. Bubble gum. Lipstick. Rubber ball. Neon pink highlighter. Children's aspirin. The over-the-counter chewables I'd take for the ulcerous pains I'd suffered constantly in my twenties through my forties (for all the good those chalky pucks did). My babysitter's umbrella. The cover of one of my sister's magazines. A swim cap in the locker room at school. Howard Johnson's peppermint-stick ice cream (Howard Johnson's also gave me orange and blue). An angora sweater, worn by a girl whose name I forget, but who was the first in our grade to develop large breasts; poor thing. I remember her sweater's wooly, pink cilia in the classroom's sunlight. Nurses' scrubs; the nurse who took me in for an X-ray when I broke my wrist; when my father was angry, I got hurt. Or doubted that I truly had. Or disliked my lack of stoicism. A salmon-colored linen shirt I wore when I was briefly—suddenly, embarrassingly— fashion-conscious. My cover for Beauvoir. Pink and sex. So much pink there, both anatomically and in the accessories and trappings. Gendered pink. Or perhaps, with this painting, pink just happened to be close at hand. No conscious program. Conversely, I *do* know how and why I choose notes and words, and am quite capable of explaining and defending those choices.

(Pink, as it happens, is my favorite color. Though 90 percent of what I wear is blue.)

The paint smells rich. Soapy, medicinal. Voluptuous between my fingers. Cool drops of it land on my arms I wipe a drop away that is running down my forehead The sound of it, burping quietly out of a tube, the scrape and whine of the trowels, swishes of my brush. When I look at this pink, something also happens in my teeth; deep in the back corners of my mouth. A pink sensorium. All these sensations emerging from, and coalescing in, a specific optical space. My pink, its cruella (Proust's Parma.)

Overpainted the next one *five* times. The first layer was a magnificent neon orange. The kind of orange that has a cheery barbarity to it. I like that the orange is four layers buried (a secret, but a *good* secret, an enjoyable one, like an anonymous act of charity or a private sexual fantasy). The new colors are much more muted, better dressed. Better socialized.

Pencil: adding thin lines. They are unusually straight. Fastidious. No, I don't like that at all. I tape a pencil to a broom handle and draw from a distance. The result is satisfying. It all looks like nonsense again.

Nonsense: the painting is neither true nor false.

Meaning: when I was a child, piano teachers would overlay dramatic events, theatrical exchanges, and various settings on pieces I was learning. (Why were rustic milieus so popular? So many "babbling brooks" Is it that the *Pastoral* Symphony is such an important monument in programmatic music? *Der Müller und der Bach*? *Peter and the Wolf*? *The Lark Ascending*? Rameau's *Birds*? "Oiseaux Tristes"?) Babbling brooks

aside, I'd often be told something like "Here, you should imagine a character saying, 'Why don't you love me?' and a second character replying, 'I do; I do love you!'" I had to actively forget such scenarios. If one understands music, one knows that the shape, key, underlying harmonic structure, dynamics, articulations, and context of a melody, say, are what matters. Ta ta ta ta ta? Ta TA tata! Ta TAAAA ta ta! This, these (syllables?) form a more powerful, deeper translation of a music's meaning than any putative setting or pretend dialogue could. Notes speaking only to other notes. Most of the evocative titles great composers overlay atop their works seem like afterthoughts to me, and diminishments of the (essentially nonprogrammatic) notes they've written (the "Lebewohl" in the *Les Adieux* Sonata, etc.).

74.

I once read a review of an art exhibition in which the reviewer wrote that every canvas is a transcription of the artist's day. Wrong. Unless the reviewer meant this narrowly, in the sense that each painting is a transcription of the exact ways in which the artist applied paint to a canvas on a particular day at a particular moment of art-making when in a particular mood and situated in a particular setting. If this was the critic's intended meaning, the statement is syllogistic to the point of meaninglessness. It adds no new information. Yet, again, these paintings of mine must intend to say something. I consider trying to determine what this something is, and then I think: Who has the time? I'd rather be painting.

This new brown painting evokes a *particular* brown memory. A memory of walking with my grandfather as a boy. It was winter, and he was wearing his dark brown fur coat, which (although I didn't know the word "mothballs" yet) smelled like mothballs; naphthalene. His pants were dark brown flannel. He was holding my small hand in his, and, looking up at him, I could see that he hadn't shaved properly (discrete tufts). It is facile to say that when I see a certain shade of brown, I think of him. Even if it is true. And the association is of safety and warmth; the feeling of his hand, padded with age; the rippling sidewalks of my hometown that we walked on, broken by the roots of the maples, oaks, and sycamores (sycamores like those that lined both sides

of Memorial Drive, at parade rest); the sound of my grandfather whistling, which he often did; the entire history of his son's (my father's) degradation; the tragedies my grandfather and grandmother endured during the war, before my father's birth, life, illness, and death.

The war was never discussed. Yet its effect was transmitted forward, as through some heritable trait, passed on from my grandparents (with whom we eventually shared a house) to my father, and from him to me. The pain reached me in a vague, attenuated form. I try to remember something my father once told me about his parents, something regarding the stoic silence with which they bore their injuries. (Was it tact, actually? Was there also some element of shame as well? If so, how absurd. How heartrending. My own shame is redoubled, thinking this.)

"They agreed to never look back, only forward." This is an idea that now feels disappointing. Or rather, it's the words used to express the sentiment that feel unsatisfactory.

(This sentiment is the opposite of the more common motto "never forget.")

My grandparents and my mother never spoke again after my father's passing. I was still too young to understand really: What did I know about death? Or estrangements? (There would be more in my family to come.) Of course, it is obvious to any idiot that anger is easier to feel than grief. I loved my grandfather. And I loved my mother. Did they ever love each other? Or was their love just transitive, my father as the middle of the equation? In the aftermath of his death the terms were sundered.

I was tasked with getting my father's ashes from the hospital. I got in my car, put the urn in the passenger seat, turned the ignition, stopped, looked over, shook my head and pulled the seat belt across it.

There wasn't a real funeral. No pews, no dais, wreaths. Some people came to the house. Not many. A large dinner party's worth. Some words were spoken. I played Brahms on the piano. It was a nonevent.

I have heard that my grandfather had my father's ashes interred in a large cemetery in New Jersey somewhere. I've never seen my father's grave.

I would like to be buried (1) somewhere beautiful, like in the clearing in the woods behind F.'s childhood home, and (2) in a place where my loved ones can easily visit me, for their sake, not mine. I would like them to be able to cry at my grave . . . a site where they can work through—for good or for ill—who I was and what I meant (to them).

I imagine that my father would've hated the cemetery where he was interred. Because of where it was (Nowhere, New Jersey) but mostly because it was pedestrian and ugly. Things, for Dad, were beautiful or they were ugly.

My grandfather and grandmother, when speaking of someone, would say, (1) "He is a very smart man" or (2) "He is a very stupid man." There were two kinds of people. My dad also had this proclivity for binaries. Just as strident.

One of the reasons, I have discovered, that I prefer painting to design is that a painting can be ugly. Interestingly ugly. Compellingly ugly. Though a painting may be sold, a painting sells nothing other than itself.

75.

Today, I got in the car and took off just to feel the air in my face. I drove through the hills until I came over a rise and saw a beautiful town. Bright houses set against a dark mountain. A pristine Unitarian church like a wedding cake. The closer I got to the town though, the more run-down it all became, as in a time lapse: the bright whites fading, yellowing, flaking. There was no one around, and the general store and post office were boarded up.

As I drove out of the town center, I saw a gorgeous hand-painted sign. It said "Chicken Crossing" in vermilion letters on a mustard-yellow background (great combo). There was also a rudimentary chicken silhouette in black. Suddenly I wanted this sign and wanted it bad. Did I identify with the chicken? I don't know, but I think I will drive back there tonight and nab it. No one lives there anyway. Other than, presumably, a chicken.

I thought that my next painting would be mustard and vermilion, but it isn't. It is black and blue (obvious combo). Once again I arrived here circuitously. I scoured, scraped, washed, and overpainted this new canvas twice. Its first layer was originally a wonderful olive green. It occurs to me now that this black and blue, like all my backgrounds, is changed as a result of my knowing what lies beneath it. I like that this olive green persists as a kind of presiding spirit; a spectral presence in the work. What lies beneath. The accumulation of layers. Cores and crusts and mantles. Once again: painting as diary.

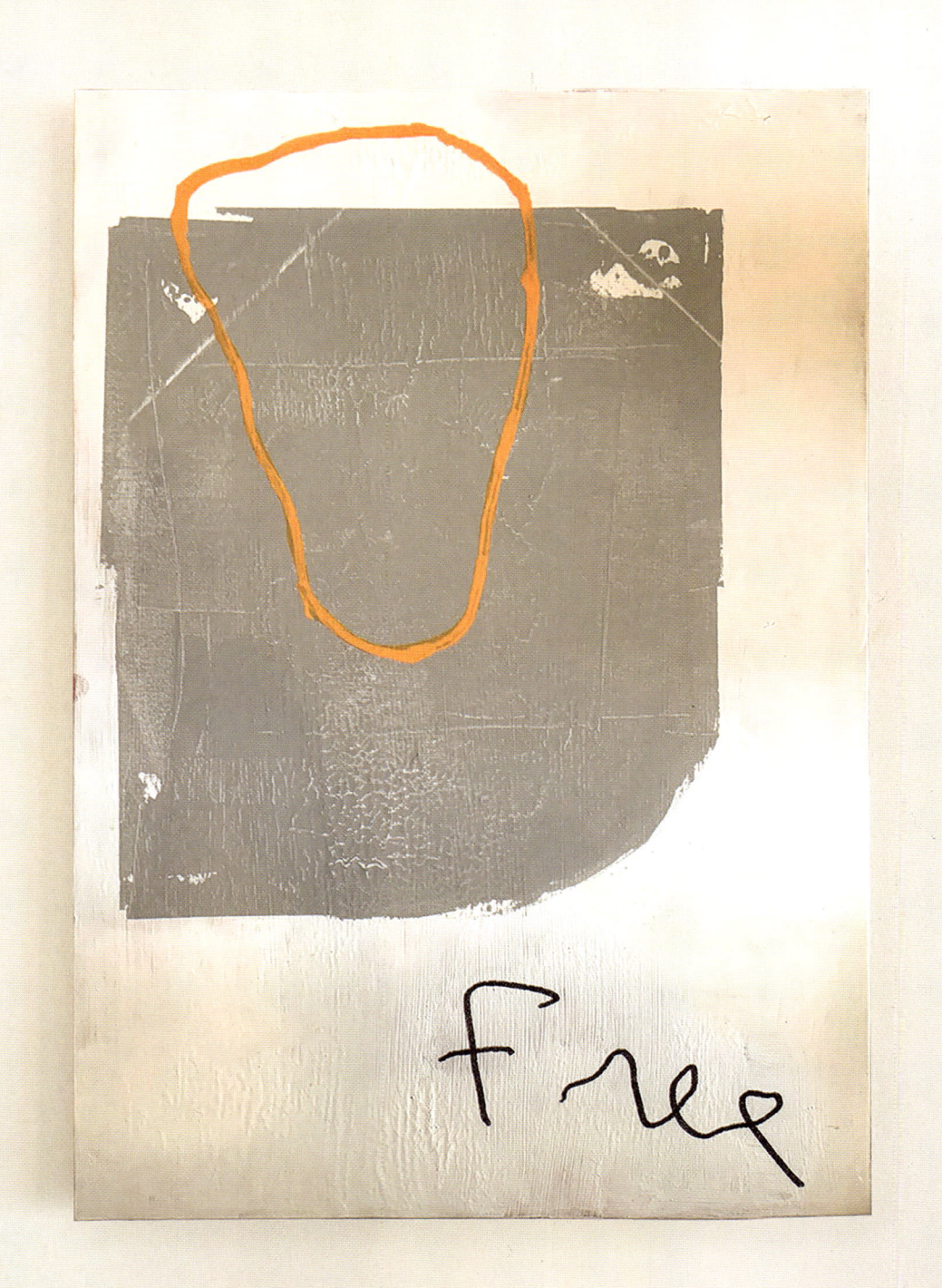

Finished, and stood far away to check if the proportions were correct. I was about ten feet away, my back against a rough wooden beam. The painting resembled something—a word, a symbol, a person, an exclamation point, a gibbet, a French horn, a steam engine . . . I couldn't nail it down. Despite such indeterminacy, I thought this painting—and the recent work in general—was becoming better balanced. The colors were speaking to one another. I also saw a lot more empty space than in the previous works. This empty space is an experiment, but I like how the paintings feel unforthcoming; pregnant. The "unforthcoming; pregnant" bit is what I would like most to achieve in my fiction, and the thing I find most difficult to achieve. (Certainly impossible to achieve in a journal. And antithetical to a journal's purpose.)

76.

Looked in the mirror today and thought again: Damn, Peter. You look good! I'm still tanned and lean. (I think of Pepys's diary, where he remarks on how fabulous he looks in his mourning clothes.) This time I enjoyed my vanity. That I cared again.

Scouted out the town of X. More or less falling down around itself, but the bones are beautiful. It sits high up, over the convergence of two rivers. The buildings are made of brick. Singed. Sooty. Old factories. There is so much warehouse space here, which leads me to think I could find an empty one to paint in. Maybe to live in, even after the pandemic ends. Maybe never

go home. You could tell that this town thrived once. I would guess—given its geographical position—that is has probably enjoyed several periods of prosperity: one (I'd imagine) driven by river commerce and one driven by the rail lines that hug the riverbanks and terminate in a massive lot, filled with the shells of rusting trains. The town clusters around a single road, then, surprisingly quickly it crumbles away. I don't find a real estate office or see many *for sale* signs, though there is one on the old firehouse. The firehouse has a tower. I've always wanted to live in a tower (Stephen Dedalus).

F. had put me in touch with an artist who lives in this town. We speak on the phone. He's friendly, if a little eccentric. Turns out he was part of Warhol's group. One night he and a couple of friends drove up for a party there and never left. That was the seventies. The man is now a kind of self-appointed cultural spokesperson for the area, and his yearning for new blood—and the potential revitalization that might come with it—is evident. My sense is that he may be literally the only artist left there. I buy a bottle of wine at the gas station.

I am heading back to my car and there is a young man sitting on the stoop of the minimart. As I walk by him, he says to me, gently: "Bite me; why don't you bite me already." There is only the slightest lift at the end of the sentence ("me already"); the hint of a question mark. It is surprising how, as a statement, it's an insult, yet as a question, it's a come-on. (Or perhaps this man was genuinely curious why it was that I didn't bite him?) I keep walking and drive back to the house, thinking of ambiguity.

I also clock that this man was nodding out, most likely using.

77.

I have this line about my paintings. I don't say it out loud. "I don't make decisions, yet what I do is purposeful." Meaning that—despite all that is haphazard and chaotic in my work, and despite my recent protests to the contrary—there is still some supervising intelligence.

Some cashews. Half a banana. Coffee. A small bite of the cold chicken left on the counter.

This part is critical: I make decisions, and those decisions are predicated upon a feeling of "knowing." Knowing what works and what doesn't. I haven't a clue what the basis for this supposed "knowing" is, or how it is that I come to know what-it-is-I-think-I know-about-what-works-and-what-doesn't-work-when-painting. Perhaps I am wrong to trust these feelings? Yet they persist. And without the innate sense that a particular painting is good or bad, I would cease to feel the requisite compulsion to make paintings at all.

This knowledge may be my primary motive here. Not the final painting itself, but the thrill of that "knowing." It is a strange feeling. And familiar.

I have sex with K. again. It surprises me. The urge. This, too, has returned.

Wittgenstein's journal entries on masturbation. (I think of him often now. His all-consuming intellectual drive, his secret queerness, the suicidal urges.) Strength of his sexual desire undiminished by his depression and suicidal ideation. Mine too. Sex now seems an important manifestation of a life force, one that the awfulness can't tamp. How is it that my horniness survives the general deadening, its sensory carpet-bombing? I feel the lust like a white wire through my body. Erections proof of life or mockery of it?

I often begin a project with a clear image of not the finished work but rather an image of who I will become once the project is complete. I will be, broadly speaking, a me who is better, smarter, more accomplished, and thus better appreciated. It is a me who is (finally) proud of himself.

One shape. Is this enough?

Aleatory art, automatic art, etc.: seems too easy. A way for artists to excuse themselves from heavy lifting. But I believe that life itself—devoid an apical, mystical intelligence—is random. Haphazard and unpredictable. The pieces just falling where they fall. How to square? (I think this while contemplating the shaky square just painted with my left hand.)

My disclosures couldn't possibly be interesting (even unique). If this journal were to be found and read by someone, that person might read until—irritated, bored to tears—he'd ask himself: Why should I care? And why should he care—snoop, thief, spy?

These accounts, whatever they are, like the paintings, are examples of creation as excretion. An "account": what is paid out and received. All transactions in devalued currency.

Acrylic, grease pencil, ink, rainwater, dirt

Acrylic, pencil, rainwater, dirt, whiskey

Acrylic, acrylic pen, spray paint, rainwater, dirt

Acrylic, pencil

78.

Spurt. Purple. Glop. Orange.

The wind blows through the land, stretching and then fracturing the light. Now I sit outside the kitchen on the millstone every morning, sometimes with R. and V. Sun on closed lids causing a smile, as if activating a hidden escapement.

Experimenting with neon green, an alien green, but then (almost immediately) wash it off. More gesso. Then: gold.

Despite their variety, I am developing a deeper language in each of these paintings, step by step, and even, collectively, a style, a method, a mode of speech. They are starting to look as though they were all made by the same person and betray that sneaky, underlying supervision. I try to ignore this. Instead, I think of them as "doodles."

Gold!

Painting with the canvas on the floor. I move around it in right angles, like a rook.

RB has drawings in his book that he captions "doodling." The drawings aren't doodles though. They are better, more purposeful than that. But the caption indemnifies him against aesthetic judgement.

I, too, would like to say that I am "doodling." But this would be equally untrue. There is real effort here. And even though I don't understand what the purpose of these paintings is, I can sense they have one.

Do those who would judge me feel the same implacable hunger I do? Have they been subject to that driving, destabilizing, creative need?

I have been starting and finishing a new painting every day.

79.

Did not drink today. Not a drop.

"You are a painter now?" Returned to social media but only to post these works. I do not linger. Anxiously, I throw a photo of a painting into the room and skitter away. Post and run. Some friends have written me to say they are both amused and amazed by my having made "yet another pivot." I never know how to respond to this. I received the same sorts of comments when I left music for design and then left design for fiction. Each pivot felt like a failure to me. Somehow, to others (maybe only a few, but still) it appeared to be some kind of deplorable machismo, or an overreach; to some others, a triumph achieved.

But if only I could have been the man I'd always wanted to be—the man who played Bach, all of Bach, every last note, played all those works onstage and on recordings, played the works the way I hear them in my inner ear, ideal renditions, played them with virtuosity but also with sanctity, honor, love, subtlety. Played them selflessly as a monk recites prayers. Interpreter of Bach. Devotee of Bach. Avatar of Bach. Sated by Bach. Bach's acolyte. Everything short of this has felt to me like

failure. I realize that this fact (the fact of my—what? Ambivalence or even scorn for other media?) might make me sound like an asshole.

Anyway, putting aside *the stink of amateurism* that hovers around those committed to more than a single art form, what I am is neither designer, nor writer, nor pianist, nor painter. I feel, right now, that I am nothing more than the daily management of my mental health. Painting here is yet another symptom of my chemistry.

(Aesthetic determinism.)

Dilettante or no, I am now come around to the thought that these paintings may have merit, and this newfound confidence is the reason why I have begun to expose them to the light. This must be a sign of better health. (NB, I've been fooled before.) It is also a sign of my precipitous mood swings; between confidence and abjection. Between life and pain.

When I put my feet up on a bucket, I saw today that three of the toes of my right sock were orange and black. Stepped in it again.

(I imagined a writer inadvertently covering himself in words.) I remember a famous writer, N., telling me he wished he could smear readers with words. Like a lotion. (Did he mean as a salve?)

Worked up a real sweat applying layers of paint on a new piece. My arms burned from holding up the trowels for so long. My back ached from being bent over. Painting is exercise. Not "an exercise in . . ." A physical workout.

I can't stop the analogies from coming. Something will happen and suddenly: "The dead are like birds," or my

eyes in the mirror are "hard as buttons," or "lacquered fields," "phosphor trails," or painting is "the breaking of a covenant I've made with language."

It is said that infidelity breathes only its own oxygen. It is bracketed. Hermetic. Nothing intrudes on it. This is what makes an affair desirable. For me, despite my newfound love of painting, I think it may be less a question of love, or hermeticism, and more, also like an affair, a case of, again, relief *from*. The "relief from" in this is case is writing, music, fatherhood, marriage, professional identity. But does the relief rest on the knowledge I'll return to them?

I think it over and over. I do not know what a painting is at all. I don't know what a painting is, or why it is. I do not know what a painting is for. This part is important and leads me to, yes, a disclosure. A confession. Which is that—though I am now *interested* in fine art—I am *unmoved* by fine art. All visual works, actually. None of it elicits a deep emotive response. This has been true since I was a child. There are slight satisfactions. Appraisals; tranquil assessments, associations, etc. . . . yet I simply have never been truly touched by, say, a painting. Not once.

R. is sick. Everyone in a panic. Can teens *die* from this thing????

It's a head cold!

Acrylic, butcher paper, pencil, ink

Acrylic, pencil

Acrylic, pencil, coffee, whiskey

80.

Ask me what a piece of music is for, and I know the answer. I have been shaken by music. Music has walked me right up to the numinous. It has angered me. Made me ashamed. Pried me open. Breached my deepest solitude. There is a passage in the slow movement of Beethoven's *Hammerklavier* Sonata that is so hushed, and so slow—so slow yet constantly slowing more, slowing impossibly—that playing it or hearing it is like being present at the heat death of the universe. My heart breaks. I cry onto the keys and must stop. I always cry at that moment. There is another passage, in the same movement, a key change of such sudden tenderness that it has become necessary for me to play this piece only in my own company. And I play it only once or twice a year. There are other pieces like this.

Painting. It doesn't make me feel much of anything. Looking at a painting is, for the most part, like looking at any other inert object—toothpick, rock, fingernail clipping, workstation, drainpipe, doorbell, brick, fork, pocket protector . . . My reaction, emotionally speaking, is more or less flat (despite my curiosity about painting). I haven't the foggiest idea why. But the requisite nerve endings—the ones I need to react emotionally to visual art—are numb or dead. I'm locked out. It is so easy to make me weep these days. You'd think the paintings would. Maybe I like painting because it elicits so little.

My lack of emotive response to a visual work of art also does not contradict my earlier assertion that I know when a painting "works." That I have (or feel I have) some innate understanding that a painting *can* work.

(Though, again, a piece of art "working" could not be a more different experience from the experience of a piece of music "working." With painting, I merely note the fact.)

Another therapy session. I need the therapy less now, I don't yearn for it. And something in the remote format has begun to bother me. I can see my own face on the screen. Explaining to my therapist how lucky I am to have defeated my depression, I cry under my own gaze—a crying which, for me, becomes a curious spectacle, a kind of performance, a mise en abyme.

Acrylic, oil, grease pencil

Acrylic

Once, many years ago, a great aunt of mine wept openly upon seeing a Kandinsky in the Museum of Modern Art (I wasn't there but so I was told). This response of hers is as foreign to me as is possible. There is a veil drawn over it. I can better understand Mongolian, the pinging of bats, or the chirrups of whales than I can understand those tears.

81.

Over the past few days, the colors of the hillside are changing. I don't mean the colors change with the path of the sun—morning to night—though of course this also happens. What I mean is that each day brings a completely new set of hills.

(RB: "Do not all the colors in nature come from the painters?")

I'd like to write this journal as if I were constructing a show. But for me alone. After the show was arranged and hung, I'd walk it, looking at the days' brief entries, taking in each at my leisure, and then, when I was done, I'd constellate them. And so finally arrive at understanding. Collectively they would form a through line. Maybe not.

Rooms? Memory palace?

Collected kindling in the woods. Brought more wood from under the barn and stacked it on the porch. The logs don't smell like wood but like soil. Each with its pale green archipelago of lichen.

Pieces, and "pieces": right before the pandemic drove us out of the city, I heard a pianist perform Bach's unfinished *Art of the Fugue*. When the final fugue in the set came around, I waited for the music to trail off, as it does in the score (Bach died while writing *The Art of the Fugue*. Its ending is shocking to hear. The last of the fugal subjects is a motif that spells out Bach's own name: B flat. A. C. B natural. (The German B-natural is called "H.") Bach's epitaph. The notes sound—BACH—and then Bach dies. Or God strikes Bach down for hubristic overreach, for inscribing his name upon the (impossible fugal) deed like a criminal leaving behind a calling card. And so: this sudden silence. (It's so loud, this silence.) Yet on the night of that particular performance, there was no

silence. The pianist kept playing, past the "ending," i.e., he played notes Bach had never written. He completed the fugue himself. I was shocked and looked around me. No one seemed dazed by this violation. This was, of course, because few audience members knew what was happening. Fucking Christ. Idiot audience. Lunatic pianist. Why would anyone want to complete a perfect fragment?

I think that each painting I am satisfied with is one that is, on some level, unfinished. Meaning that with each of my "good" paintings I knew "when to stop." (Dad had a point.)

Fragments, shatterings, millions of little pieces, epigrams, aphorisms, death's intrusions, wreckages, cut-ups, the puzzle, the feed, character limit, text, email, chyron, email, swipe, the digital intelligence trained on the data set, control systems, cybernetics, poetry's semantic compression, stanzas, brief bursts, the list, the alphabet, the microscopic, the subatomic, the entropic, the album and its tracks, the fugue (the prelude without the fugue), moments musicaux, fugitive pieces, microcosmos, index cards (methodology as finished article), the "form" (in the bureaucratic sense), echolalic spasms, labors of the fractured consciousness, the coherent whole malfunctioning, the diary.

(Wilkomirski's book was actually called *Fragments*.)

82.

I make no claims about the therapeutic worth of this journal. I also make no claims about the aesthetic worth of my paintings. It may be the case that these two practices — journal-keeping and painting—have the same aims and the same merits. It may be that both are forms of disclosure, and therefore therapeutic, yet the surprising thing to learn would be that their worth, in both cases (to RB's point), is purely aesthetic.

Walk: crows in the cackling in the trees. Pale moon sitting on the hill. No enlightenment, just me.

This morning I stayed clear of the barn.

I scraped the mud from my boots and fixed one of the soles by gluing and clamping it. I cleared the ashes from the fireplace and put new batteries in the smoke alarm. I took the kids to a nearby chocolate store and bought myself some extra love. Then I thought, actually, no buying necessary. They may be disappointed in me, bewildered, hurt, furious, indifferent . . . but even so, the love is there, a subterranean spring.

Today I did return to what I've come to think of as "my studio." Everything was as I'd left it. I swept, scraped more errant paint splotches off the floor with the fastidiousness of an archeologist at a dig. I put down a new tarp and began to prepare two new canvases (back to gesso, and a cessation of violence between their surfaces). I scooped the thick, white gunk out of the bucket with a palette knife and glopped it on the surfaces, spreading it slowly with a large brush; first in heavy, rough horizontal strokes to cover the canvas completely. After, I was delicate with the vertical strokes, as if brushing a child's hair.

Went to the supermarket. The kids love those sour cream and onion Pringles. Ate half the tube on the way home.

When the priming process is complete, these future works—white and gluey—get tossed out onto the back field to dry under the brutal sun. An hour later they are ready to be painted upon further.

I have come to realize something, something that should've been obvious: that there are several ways to paint a background color. What I mean is that a solid background is anything but. It betrays the remnants—the forensics—of the painter's gestures. At first, I painted these backgrounds willy-nilly. Now I pay careful attention to what direction my brush travels. Often, a painting seems to demand that all my brushstrokes proceed in the same direction, like the bowing of an orchestra's string section. I wonder if this new fussiness is the beginning of the end of naivety. Either way, I am happy with the results.

The sun is setting; another work finished. The last few paintings were intended as explorations of negative space, but this one has radically changed course. "Dousing" a canvas again. Everything in this one is paint. Words and words and words; dripping, seeping, spreading. If this new painting were a book, or a person, it would be logorrheic. Now, scraped, it is a thicket of yellow and black. The finished article looks like something that has been worked on by the elements and shot through with natural history, the residue of age and endurance. This is because of the brushstrokes. Their rhythm. God I love it. It's my favorite.

But then a return to empty space. The weight of it.

Why did my father avoid negative space? Why did he proclaim, as a maxim, that one must fill it? I think of that Barthelme story where a balloon is inflated to the size of a large city. Crowding everything out. I remember the line from the story: "monstrous pourings." I think now that if you fill a space, you leave no room for other voices, for questions.

I pulled the door closed and got to work. I felt at ease and realized I had felt this way since the moment I had entered the barn. I concluded, later, when walking back to the house, that my contentment was latent in the barn itself. It lingered like a perfume. My newfound joy has

this power to manifest in myriad ways, surprising ways, and to act upon everything.

Today, rather than paint, I think, and write.

Wittgenstein took two books with him to the front: Tolstoy's *Gospels* and his own *Tractatus* (in progress). The *Tractatus* would become a meticulously logical mapping of the world, the world's constituent parts, the sum of their configurations, ending with the famous gnomic line concerning the limits of the sayable. The *Gospels* is a work of spiritual metaphysics, meaning the kind of thing that should, according to Wittgenstein, be passed over in silence.

"Saying the unsayable." This is a common phrase, which means "saying something that is not supposed to be said; isn't polite to say." I'm interested, though, in taking the statement literally. I want to say what is literally impossible to say. Though I suppose I am also interested in what is possible to say but impossible to understand (private languages).

Most listeners don't realize that in the middle of Schumann's pianistic warhorse, *Carnaval*, there is a section that is not played but rather passed over in silence. This silence consists of double whole-note rests. *Pitched* rests. E♭ C B A (SCHA) and A♭ C B (AsCH) and A E♭ C B (ASCH). The pitches do not sound. There are no dynamics. There is no tempo. No articulation, key signature . . . Nothing. A cipher. What these (potentially silent) notes "spell" is the name of the hometown of a woman named Ernestine von Fricken, who was Schumann's first love. Was she so dear to him as to be inexpressibly dear? Was the intensity of this love too much to disclose fully? I don't know enough about

Schumann's life to have an answer but could hazard a guess.

And though it remains somewhat unclear whether a pianist should play these notes, Clara Schumann, Robert's wife (muse, a composer, and a preeminent virtuoso of her day), insisted that these rests/notes should never be heard.

83.

I've read that any marks on any surface have a rhythm
to them; one which takes time to unfold. The difference
of course is that one can see all the beats at once
(gestalt). The eye can encompass.

It can also travel.

It can also carve and shatter and reconstitute.

Dad was a collagist.

Acrylic pen on linen

Acrylic, spray paint, marker, pencil

84.

Today the sky was sky-ing, the woods were wood-ing, the earth was earth-ing, the wheat was wheat-ing. Cool breeze, the warm light weighed on my lids. There were two suns in the sky. There's a word for this effect, I know this word but have forgotten it. Swam in the pond for the first time. The mud was thick between my toes, but the water was clear. I lay on the dock in the pond's middle point and dried in the hot air like my paintings. Swam to shore just as a dog came through the property. Not Mater, which was a relief. White with brown spots. Friendly. We cavorted. K. made a lasagna for dinner.

(Double refractions.)

Again I want to say that when a painting has been overworked, it's better to just throw in the towel, toss the canvas, and begin anew. I've overpainted sections of the one I am working on now multiple times. It's small and becoming . . . fuchsia. I've rearranged its components over and over; stripped for its parts. I scraped the paint right down to the canvas's last threads. Even, in places, through the canvas entirely. Each time I finish for the day, I think I am done. Whether it is a book I am writing, a design I am working on, or a composition—the work can become like a prisoner of war after days of interrogation and torture. It will tell you exactly what you want to hear, confess to anything. Better to put it out of its misery.

"Know when to stop" is not the same as "know when to give up." By the way.

I paint my most convincing self-portrait. A figure, standing alone above the waves. As with all my paintings, I did this unintentionally—by dripping and troweling.

I was sixteen and had traveled to Greece. I visited the ruined temple at Cape Sounion where Byron inscribed his name into a column and where King Aegeus—father of Theseus—threw himself into the sea in the mistaken belief that his son had died (the black sail: death by semaphoric typo). Aegeus's suicide became the toponym for the sea upon which he broke. I still have a photograph, taken on my old Olympus, of the precise promontory where the king sat. He watched day after day, awaiting the moment when a single color would breach the horizon. I saw him, the distraught father, cross-legged on the very edge of that outcrop. I imagined he didn't jump but, there at the very edge, merely leaned forward. Such a simple thing. Barely an action at all.

A week after I'd arrived in Athens, I was on a sailboat upon that same Aegean Sea. First port of call was an island. Upon mooring, I tied up my clothes and a bottle of gin in a plastic bag and, with the bag in one hand, swam to shore. My older cousin D. and his impossibly cool friend C. had joined the trip by then, after having traveled in northern Africa. But that night they were god knows where, doing something that did not involve a younger cousin. So I was on my own. Later, drunk, I smoked a cigarette on a dirty little beach and looked out, once again, on a sky that crushed me. There was a sign on the beach warning of riptides (in Greek, but the picture made it clear). I waded out, until I could barely feel the sand with my toes. And then, that little lean, a slightest shift in weight, and I began to drift. I was beyond the harbor. The island was nothing but

tiny lights, leaping above and diving into the waves like iridescent fish. I was treading water. All I had to do was go limp and that would've been a series wrap. But I suddenly panicked, and started swimming, and barely made it back.

This new painting I think of as *Mykonos*, because it is the color of the island's houses and generally speaking the national color of Greece. (Joyce wanted this blue for the cover of *Ulysses*, though his cover turned out to be a greener blue. Not that he noticed. His eyesight was terrible.) (Anyway, *Mykonos*; but the title is a secret one.)

85.

My productivity is now astounding, even to me. What can I make in the time I have left in this barn? What colors, what shapes? I am in such a rush.

What, if, at the end of my life, all I've made is a lot of *things*? But these are the thoughts of a depressive. Without even trying, I smile them back to their proper depths.

Today, again I traveled from New Hampshire to Vermont, over the Connecticut River, which marks the boundary. Drove under some railroad trestles. Spray-painted on the overpass were the words "I love Rusty." This tag has been there as long as I can remember. As a kid, I'd take the Greyhound bus up here to where F. lived, his family filling in for my own, weekends, holidays, whole summers. The time I spent on F.'s farm

was the happiest of my young life, and on these bus trips I'd be vibrating with anticipation. Once, a ratty old man sat down beside me. He told me stories of his life riding the rails. This had, by then, become too dangerous, and so he began taking buses around the country instead. He told me that he'd get off wherever, no plan, and sleep rough. Why did this man tell such things to a ten-year-old? (I would later learn that when F. was young, his depressive grandmother was sent away to be institutionalized. Her children put her on a bus, but she disembarked early, checked into a motel, and killed herself. F. did not know this story until he was the age I am now.) Me, I would always disembark at exit 3, right near the "I love Rusty" tag. F. and his father would be waiting for me in front of their idling truck. Passing by this morning I was amazed the words were still there. Appropriately, the steel bridge and the overpass are now completely rusty, the graffiti perfectly anticipatory of my feelings toward it. My father, earlier in his life before he'd discovered collage, made sculptures out of old steel, only the rusty stuff, which he and I salvaged from a junkyard outside of Boston. The scrappiest of scraps. That was in the late 1970s.

During this "scrappy period" (when I was a boy) I remember Dad explaining how I should learn how to fight; how this would earn me respect, prepare me for manhood (standard stuff back then). He told me about fights he took part in on a merchant marines tanker, where he worked in the boiler room. About a Golden Gloves boxer he fought in the Bronx, where he grew up. Dangerous kids who carried weapons, who'd put out cigarette butts on his legs. Obviously. I wonder now about the veracity of these accounts. They were probably true-*ish*. Anyway, he taught me how to punch. We practiced. I was bad at it. He had me punch his open

Acrylic, snow

hands, over and over, telling me this was the best way to vanquish feelings. He considered this a kindness, and in some ways the violence did help.

He invited a schoolmate of mine over, gave us boxing gloves, formed a ring with kitchen chairs, and presided over a brutal contest. The following year, some more training under my belt, I found myself in a fistfight in the dusty yard behind my school. I kept the kid at a distance with my left jab, hit him hard with a right hook ("always throw your hip"). His nose bled. The teachers came. I had won, though I cried for hours afterward. There were more of these fistfights growing up, and as I aged, each was more vicious than the last.

His love and warmth, sure. His wonderful and wondrous presence. His belief in knowing what was necessary in order to parent me correctly. But also his belief in me as gifted and thus a natural recipient for his guidance. His criticisms. His hard-line opinions. Wild swings between bottomless support and nothing-is-good-enough. Uncompromising moral codes (fundamentalism).

"You will thank me later," he would say, locking me in my room with the little piano when I didn't want to practice something difficult. And you know what? I do thank him.

You can't come out until you can play it. How could I not thank him? I play music every day now. I have done so my whole life. I'm pretty fucking good at it. I wonder if we are too lax with our children now.

Of course, he also told me, repeatedly: "Well, you'll never be truly great; a Vladimir Horowitz. Who ever could be." Mixed, those messages.

I remember, when I was young, my father had an argument with my mother. I don't know what the fight was about, but I recall how he picked up the fire poker and smashed the TV, then stormed out of the house, rattling the doorframe. Later he came home with a transparently false story about what had happened to him in the interim—a series of unlikely events, including finding a dead body in the trunk of a cab. All this was meant to divert attention from his bad behavior, and it was deeply embarrassing to me, even as a child. Strangely, it wasn't frightening.

(You couldn't get a feeling in edgewise with this guy.)

Once I said something he hadn't liked. Really hadn't liked. Anyway, this part I don't need to discuss. What happened next: The only thing I knew for sure was that it was my fault. I was in pain, my jaw hurt, but it wasn't too bad. Later he came to me crying. His apology was abject. It wasn't the first time he'd hit me. But it was a different era. The blows he struck were love. This was one way that he loved.

86.

F.'s house sits in a grassy bowl, hugged by fields and forest. The place was in a bit of an uproar when I arrived. The parakeet had escaped! We all put on high rubber boots and took off toward the woods to search. We called for it. Whistled and hooted. Looked for bright yellow flashes up in the dark branches. Nothing. The parakeet had been gone for hours. Later, as I was getting ready to leave, I saw something glint up on the

Acrylic

hill. When I walked over to the spot where the light
was coming from, I saw an empty, gold cage, its door
open, sitting on a high stool, facing the tree line. F. had
put it there, hoping the bird would return on its own.
This sight hit me hard. Just ruined me. It seemed the
epitome of hope. A picture of our yearning hearts. How
can people leave their cages open? How do they find the
bravery, through all of life's savageries?

My daughter shut her door. A relationship with a boy is
going badly. The next day, she is up and working. Back
at her assignments. Occasionally I hear a small sob. But
then she is okay. I never liked this boy.

Work started up again weeks ago. On Zoom, so it's not
like I need to return home. "Screen off." What a boon
my colleagues didn't have to witness my abysmal-ness.
If I could just navigate my real life this way: "screen
off." I think this, but then remember that during my
depressions my face must, in fact, appear this way:
screen off.

One of these online meetings—a large one—company-
wide. A colleague had to update us on the latest
numbers. She began, her voice shaky. She was so
nervous. Suddenly, she slumped back in her chair
and her eyes rolled back. Minutes went by; everyone
watching helplessly. She did not wake up. Terrifying.
We all jumped off the Zoom and someone tried calling
a boyfriend. Soon the news was passed along via
group email that she was okay. The following week,
she was there again, on-screen, to give the exact same
presentation in the exact same words. Such unheralded,
small, quiet acts of resilience are astounding.

This morning I cracked a molar.

I heard a writer say, proudly: "I don't want anyone to read my work." I wish I had such chutzpah. Or the chutzpah to simply make nothing at all. To leave the world, as Wittgenstein put it, "as I found it."

I notice I am leaning a lot. When I wash my hands, my head rests against the medicine cabinet. I hold the backs of chairs when standing. I took P.'s arm the other day like he was my great-grandson. Any opportunity to take weight off. This wasn't true last week.

Today I stood over the toilet—palms pressed to the walls—in a fugue state. Painfully distracted. Too distracted to do what I had come there to do. "Pee, you fucking, fucking motherfucker."

Summer fermenting, perhaps prematurely, and the evenings here at altitude have become cooler. So for once my fires are appropriate. The family is circled around. I'm staring into the flames, hoping for some form of hypnosis.

Bad today. I can't go back.

I am here again. It is impossible.

87.

What I need is a stronger will. To brute-force my way clear. If I don't or can't, what kind of person will I be?

A burden.

Today, I will try as hard as I can to turn back again toward life. For K. And for R. and V. For them I will try. Will defeat this living death. I *will* leave the bed. I *will* leave my mind's prison. I *will* eat. I *will* move. K. has taken the view that the paintings are a sure sign of recovery, and I will aim to satisfy those assumptions. I have to. I give her nothing, nothing. I give no one anything. I can't love. I am unlovable. And guilt will break my back.

I pulled on the shower curtain rod today. Testing it. How much weight it can hold. I cried so hard afterward. I had to leave the house for the woods. What do the birds make of my sobs?

Holy god—there simply is no getting out of bed. I am eating fire.

When I cry, the catalyst is generally one of three events: (1) nothing whatsoever, (2) the kindness of my friends and family, or (3) the loneliness I feel when I retreat from my friends and family.

There were the suicide attempts, but there were also the seizures. Supposedly I was present for my father's seizures. I would have been eleven, or twelve? I was there for his second seizure as well. Can't remember a thing. Not a single thing.

The trees and the fields: gray. Food = soot.

Awful hours.

Any vitality I have that isn't reserved for self-torture is dragooned into art-making (when I can get out of bed at all). My poor family.

Spray paint, Sharpie on linen

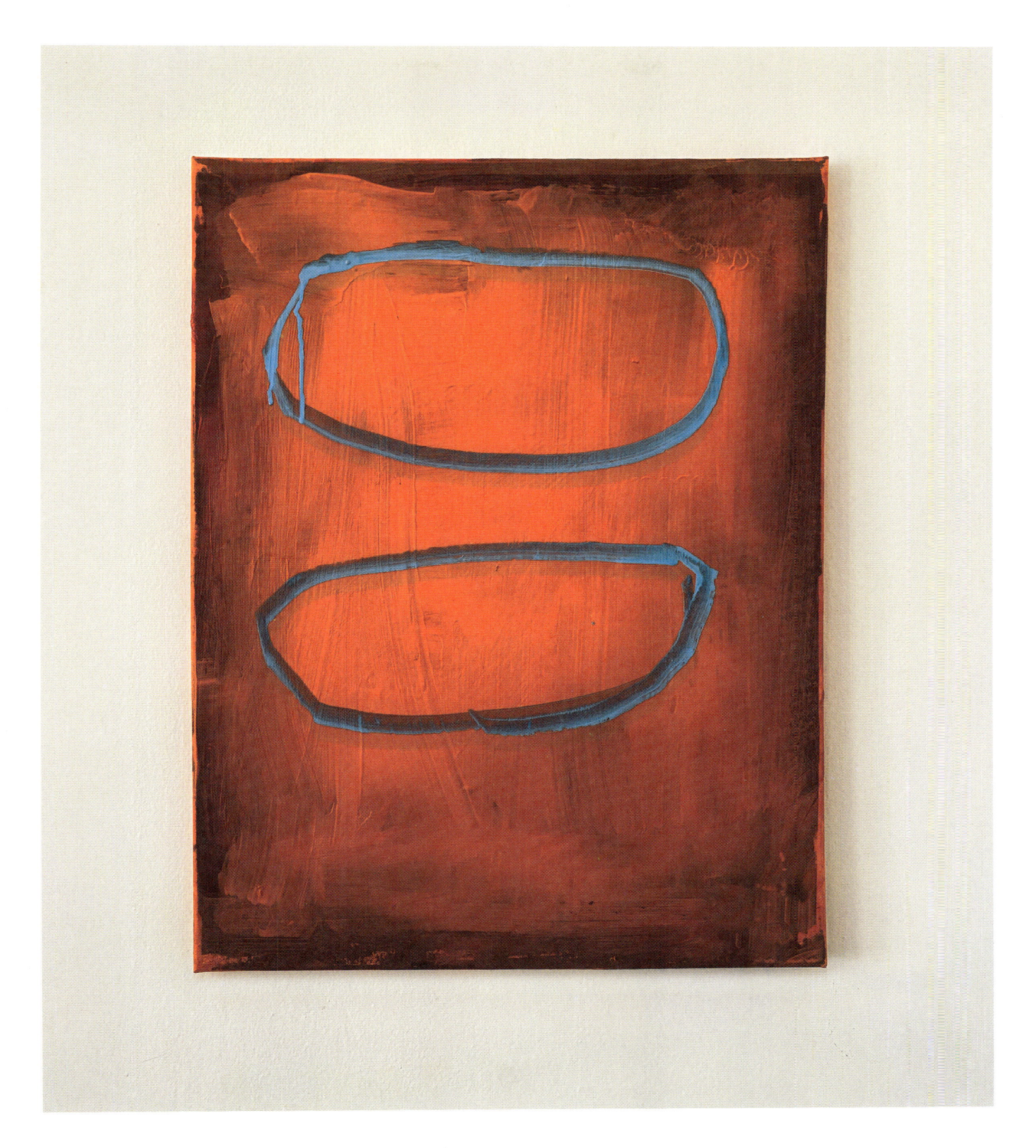

Acrylic

My childhood friends never spent the night at our house. When I asked if they could, the answer was always yes, but it never felt comfortable to follow through. There was an overall climate that precluded such things. At that time, I did not feel that this was out of the ordinary. To ask why, to think to ask, was an option not only unavailable to me but also unintelligible, much in the way that certain cultures may not perceive a thing they have no word for.

So all those sleepovers at other boys' houses. Also: all those days spent outside, roaming the town, wild, with packs of friends.

True, once in a blue moon a particular friend was allowed to spend a night at my house. Generally, it was F. Later, much later, F. told me that he knew all along about what was happening in my house. His parents had told him. My father thought (Mom told me after my father's death) that F.'s parents letting F. in on the secret was an enormous betrayal.

There was also a distant relative who tried to tell us, my sister and me. "Your father is very sick . . ." My parents ceased speaking with this woman, and I grew up being told she was a terrible person. (She was not a good person, I think. Because of this. In retrospect.)

No answers until my twenties. And even then, the account was sketchy. You could count on one hand the number of people who were ever let in.

I went with a friend and our girlfriends to the Carolinas. To a beach. We arrived, spent a few hours out on the water, got back to the house, and the phone rang.

Just like that. We arrived: I needed to fly home. My father had an accident. We never spoke about what kind of accident.

The following summer I was living on another beach, with friends. I had a job as a dishwasher in a seafood restaurant. I was the dirtiest person in the kitchen and loved this. All the cooks, waiters, and busboys blessed me as a mascot. It is still the best job I've ever had. We went to the beach every day. We were tan, fit. Sexy as hell. We'd skinny-dip in the ponds on balmy nights. The sun and moon shone on us. When it rained, which was practically never, we'd sit on the porch of our ramshackle house and play solitaire. We had four decks of cards. But then one day the phone rang again.

Wittgenstein had three brothers who killed themselves. One jumped from a boat. Another poisoned himself (potassium cyanide). The third shot himself at the Western Front.

Small forays out of the bedroom. To the girls I "have a cold." But they surely know. They are working on a large jigsaw puzzle and will soon finish. No idea why I do this, but I've been removing pieces a few at a time when my daughters aren't around (they haven't noticed yet).

Barn today. Ate nothing at all.

When I'm working on something and it's more or less complete, I begin removing components one at a time, until the composition falls apart completely. I then backtrack one step and thereby arrive at the finished article. Only that which is truly necessary remains. But with painting, I can't figure out how to seamlessly correct my mistakes. No subtraction, just addition.

If I remove pieces from this diary, the last piece
standing—the remainder—could only be my immutable,
tortured ego. I am the only load-bearing support. Which
entry here would sum me up?

Q: Could I erase myself and leave all the life around me
more or less intact?

I also know that I withhold deeper material here.
Mystification. Naturally, we withhold facts and
feelings from ourselves. Lie, etc. For me, under the
circumstances, I feel it necessary.

A diary is only meant for the diarist. I can write
whatever I want. So there is no one besides me who
can ask follow-up questions. (Is this diary a series
of follow-up questions? Even those entries that are
declarative, or mere statements of fact? Either way, I
don't intend to ask them for much longer; so they will go
unasked.)

Family dinner. I need to *hide my shit better.*

Susan Sontag: Art tends toward the death of the subject.

Don DeLillo: All plots move deathward.

88.

I've been back on the pills. But am now out of Percocet. I did not bring enough with me.

How long does a life reverberate?

In medieval music, rests will be held as long as it might take for a (sung) line to die out. In sacred spaces like cathedrals: the sound is incredibly reverberant. Notes like radiation from distant stars.

Beethoven and his rests: short as thirty-second notes and long rests with fermatas.

There is the perceived length of a silence, which is determined by what kind of material happens on either side of it.

Silence in a work, but more meaningful silence at the outskirts. Derrida talks about such silences, in his own way. His piece on "frames." Is a frame part of the wall or part of the art?

Some sculptures sit on a pedestal. Elevation to eye level. Elevation, generally speaking. I remember a novelist saying to me he only wanted to write stories about "a man in a hole."

Fragments and silence: détaché, in string playing. The bow is changed for each note played. Legato: playing several notes per bow stroke. In conservatory— trying on the piano to match W.'s and O.'s bowing, articulations. Old Felix Galimir presiding over the practice sessions. He premiered the Ravel string quartet with the composer in attendance. Which is . . . insane. When I heard this, all time collapsed.

Naturally, my grandfather had wanted my father to play the piano. "A child's greatest burden is the unlived life of its parents." I believe this is Jung. Maybe it's just a social media meme.

Brushstroke after brushstroke. Word after word. No relief. Sledgehammering rocks; an inmate.

Once a sentence is begun, it is expected to go on. Until it ends. Its full meaning only conveyed upon completion. This force, momentum, this drive, this voltage—flowing in a circuit, word to word—it isn't merely a force. It is built into the meaning and structure of "sentence."

A sentence only lasts for a period.

Death sentence. Language: the death urge. (Is this true of fragmented language/discourse as well? Is this what fragments do; stop the clock? Blanchot again.)

In my first book, I wrote that when an author leaves blank spaces in a narrative—when he chooses to leave off description (when he keeps secrets, if you will), he provides room for the reader's imagination. Provides a site for it. (Of course, an author may choose to omit whatever he wants, but also language is such that it cannot convey *everything*.) These gaps, big and small, are what make narrative possible. A rest in music does not prompt the listener to imagine more (different notes). They are literal silences. And I believe an unpainted

Acrylic

Acrylic, spray paint, pencil

space on a canvas does not encourage a viewer to slap down some imaginary paint.

Famously, in a horror movie, to maximize fear and suspense, the moviemaker must not show the monster until the very end.

I want to die.

89.

I don't know what day it is.

I can't remember when I arrived at the house, with the pond and the field and the barn and the woods. It has always been like this, and always will be.

Heavy dismal.

Everyone will be better off. (*Self* sacrifice)

F. was brought up by his parents to believe in tiny trolls. I wasn't told whimsical myths.

Behind the house up here is an apple tree with a swing tied from its sturdiest branch. The storm last night knocked the seat off the ropes, so all that remains is a matching pair of small nooses.

I'd graduated and my girlfriend, herself off on a year abroad in Paris, left me for someone else. I was drinking a ridiculous, death-defying amount. Drunk every day and night.

Get it all down. Though who cares and what does it matter.

I decided I was going away also, and I did. First to Africa, where I wandered around Zimbabwe and Zambia, reading the same two books over and over again (*White Man, Black War* and *The Tree Where Man Was Born*). There were huge hairy spiders everywhere. I had always been deathly afraid of them. On the first day camping, I erected a mosquito net around my sleeping bag. I didn't know that you needed to secure the net's bottom. When I woke up, I was in a nest of spiders. Later, I saw a snake move over the water like the spirit of God, like a Jet Ski. I spent time at a bar where men with red leather faces reminisced about the war. I gave away my Walkman to a boy with an extraordinary smile. Mugabe would change everything for the better. I was awed by elephants. Weeks without human contact I masturbated deep in the woods (and was later convinced this was when I contracted the malaria that was only diagnosed, by K., ten years after the fact). Always the smell of smoke, but a different smoke smell from the one I knew. So hot, but always something burning. Despite or maybe because of Africa's awe-inducing size and beauty, I couldn't wait to leave. But to go where?

I was home for a few months. I crashed with friends and, hating it, decided to leave again, to Paris, where my girlfriend had lived when she left me. I went to the scene of the crime and lived in its ruined aftermath. Friends of the family advised me to stay. "You will regret this for the rest of your life . . ." they told me. But why? Did they mean I would regret leaving a father who was already more or less gone (and fervently wished to be fully gone)?

I felt selfish. *Agenbite of inwit.*

In Paris I lived alone in one room with no running water and a communal Turkish toilet. The other residents were East African. I didn't really have a real conversation for a month and a half. When I'd order a baguette or check out at the little supermarket, my voice sounded strange to me, like someone else's. Eventually I found some people. It all started to work. I developed a crush on a waitress who worked at my haunt (the coolest café in Paris, in the coolest neighborhood in Paris, and therefore the coolest place in the world). I was making a handful of francs at the piano. Playing jazz. Teaching music, accompanying modern dance classes. My expenses were practically nothing, and my mother would, periodically, send a traveler's check to the American Express office. My French was improving (I was so disappointed to learn what "faire le ménage" actually meant). I had sex with an American grad student. I had sex with an Israeli expat. I had sex with a French woman (not the waitress). An older married woman propositioned me. (I was so priggishly principled about it and said I could never do such a thing to her husband. What an idiot she must have thought me.) Anyway. It was all falling into place. Then the call came.

90.

There was a bridge over a railway track. I clambered up the hill beside it and edged onto its thin outer lip.

I had seen F. do this a year or so earlier. I'd tried to talk him out of it but was also outrageously impressed, as I was by everything he did. He is braver than me. More stable. Deliberate. Strong. Loving. My bridge crossing

was, unlike his, reckless. And I knew as much. I knew there was a very decent chance that it would go terribly wrong, but I didn't care. The point wasn't surviving. The point was the possibility, however small, of not surviving. So there I was, alone. Hand over hand and foot over foot I navigated past the vertical struts until I was dead center over the tracks. I was very high up, grabbing at whatever I could. Suddenly, a massive diesel train came on, roaring a foot beneath me. My hands were damp and my toes were aching. I almost lost my grip. I could feel my back being tugged at. The roof of the train—barnacled with exhausts and intakes—was so close. Its heat. The bridge was rattling. I could see how loose the rivets were. The train passed. I was frozen for a moment there in the middle. Eventually, I managed to move again.

Then I bought a used motorcycle. Once on the highway surrounded by cars and riding at high speed. I didn't lean into a turn. I didn't make a decision to do this, yet the act was purposeful. I skidded, and then regained control. For an hour afterward I shook uncontrollably.

Soon after, the bike broke down and I bought a used car. I was driving past a bad crash. It was near my house. A man had killed himself by driving well over one hundred miles an hour into the massive concrete support of an intersecting highway. My hands grew looser on the wheel.

Later, I got high with M. in Massachusetts—I was already dead drunk—and drove my father's old van fast, seat pushed and tilted way back, using the toes of my left foot on the steering wheel. My toes. How could I not realize that I was being drawn toward death?

I was not yet twenty-one.

Acrylic, acrylic pen, pencil

I wanted to die but was not yet ready. Will I ever be?

When I talk about my father's suicide attempts, I say "my father's suicides." What I think I mean is that each attempt was a death, for me.

I wrote a poem in my thirties, in response to the suicide of a poet whose work I admired. I likened her to an astronaut on a spacewalk. It was a description of bravery. I (wisely) did not share this poem with anyone.

When I finally, after years of silence on the topic, told my therapist about my father's attempts on his own life, I also told her I felt guilty about this. She asked why; guilty for what? I said for not staving it all off. She said I didn't know what was happening back then. Not fully. And, also, in her long experience, no one could wrench a weapon from the hand of someone determined to use it on themselves. She said it wasn't for the child to remedy the desperation of the parent.

I cried then. Not from feeling exonerated. From redoubled guilt. I didn't believe her.

So then I said, as I always do: "Well, the disease . . . he would have died anyway. It might have been a year later, or ten, or thirty, but he would've died."

That much is true.

He was younger when he died than I am now. I never believed I would outlive him—his age at death. These are stolen years.

Now I write these hours up not as a medical chart but as a police report.

91.

When I was told he was dying, dying imminently, it was a massive relief. It was something I had ardently wished for. Wished it for a decade. But I had buried this secret wish so deep that it shocked me when it finally surfaced.

I had been back in Paris when I received the call. It was the first night of the first Iraq war ("Operation Boucle d'Oré"). I was one of only a handful of people in Charles de Gaulle and one of only five passengers on one of the few planes still flying a U.S. route. When I landed, F. met me at the airport.

We arrived at the hospital and Dad had passed. I just missed it. I was alone with the body. He looked waxen and was already neither my father nor a person. I kissed his dead cheek. It was like kissing plastic. He would have hated the room he died in. It was an ugly room.

F. and I went to the piers on the Lower West Side, which were, then, a cruising ground. We ducked through a hole in a chain-link fence so that we could walk right up to the river. I looked out at New Jersey and screamed. Really—for the first time since I was a baby—screamed. I don't think I have screamed since.

Someone once told me that my grandparents kept cyanide capsules. I can't remember who told me this (A.?). It would never have been my grandfather himself. It must have been my father, which means that now I wonder if it was true. He valorized his parents, especially in light of their suffering. Is it true that they carried poison capsules with them through each chapter of their lives—from the Warsaw Ghetto to the

Amalgamated complex up in the Bronx to the house where we all, later, lived together? I suppose, having seen so much devastation, they wanted to control the manner of their own deaths.

Not very long after my father passed, my grandfather died from a blood clot. And subsequently, my grandmother began her first course of SSRIs. She lived (whether she wanted to or not—and she did not) to the age of 101.

Those capsules could have been right there, right under our roof. Where were they kept? Were the two capsules (with cyanide it's always "capsules," for some reason) nestled together in a little case or tin, the picture of how their recipients might be found after taking them? As they'd lie in a cemetery plot? What happened to these capsules after my grandparents died? Are they still in our old place? If my father had known—why didn't he just . . . I would have.

While I am out of the house picking up dinner from a local barbecue place, K. talks to R. about my depression. I have been suffering depressions since she was born, but this may be the first time the word "depression" has been uttered to my children (one of my children, anyway).

R. already knew. On some level. She knew in some ways, and not in others.

I still eat close to nothing. I had heard that anorexics and bulimics, more than anything else, crave control. This is my experience as well. I cannot halt my slide into oblivion, but I can regulate this: My intake. My weight. My hunger artistry must be, on top of everything else,

another annoyance to those around me. I leave the house precipitously during meals, while everyone else is still eating.

R. tells K. later that she has always seen "him (me) take to his (my) bed," and I wonder where my daughter picked up this antiquated formulation. When I would be in bed for long periods, she thought I was sick. She noticed that I was wearing too many layers indoors— hat, gloves, sweaters—even in summer, which confirmed her hypothesis. On such occasions she assumed I had a flu, an inflammation, something. But it was only my panic that made me cold. And my hunger. She also wondered why, when the family would go out, I would beg off at the last minute. Was I antisocial? The evidence didn't support this reading. She said she's known me to spend the majority of my time in my "artistic bubble" and so assumed I was deep in writing, etc.

R. told K. that she wasn't worried, not until my not eating started to scare her. She said, "Why is he always hurting himself?"

Back to the barbecue joint. I pull into the driveway. There's no one inside but the burly owner, who takes my order and waits with me silently until it comes up. Leaving, I see for the first time that the place is sandwiched between an abandoned storefront and a gun shop.

I was not told my father was sick, but also I'm not stupid, and wasn't back then either. The signs were everywhere. On the other hand, I did not trust the evidence of my own eyes. Even as that evidence began to mount. I ignored it, and then began to believe he was faking his symptoms in order to gain attention; sympathy.

This need, somatized. This mistrust of mine was, of course, terrible. It was heartless and unforgivable. But in my defense, my father had maintained a slippery relationship with the truth.

Later, after his death, whenever someone would tell me they were ill, I'd think they were exaggerating or lying. Meanwhile I went through several years when I was, myself, always sick. Constantly. Psycho-emotional exhaustion? My hyperactive organs of speculation (hypochondria?). Sure.

Meaning there was an extended period of time in which I was the only one allowed, by my lights, to suffer an illness of any kind.

"To have pain is to have certainty. To hear about pain is to have doubt."—Elaine Scarry

A little relief today. My drugs I think. But then Big Dark returns by evening.

Bathroom before bed. Daily pharmacopeia. Thought: it's a much smaller pile now, but I still need a pill organizer. I am old. Looked in the mirror and quickly turned around. The longer my hair gets the grayer it becomes— or has always been. The gray has been hiding.

More hair in the tub. Isn't it enough that I am pulling my hair out? Why should it fall out on its own?

The tub and the outlet.

I realize I don't know how one becomes a gun owner. I mean the bureaucracy of it. Can't be hard.

When my father finally died in the hospital, his cord was pulled.

My grandmother had, upon his death, only recently learned that he was so ill. What a secret to keep. (And from a mother.) Like everything else, I found out about this terrible confederacy of silence later.

At the end of *The Magic Mountain,* Hans Castorp marches off to his death singing Schubert's *Der Lindenbaum.* Several years ago I accompanied the singer Ian Bostridge in *Winterreise. Lindenbaum* is my favorite lied in the set to play. Its susurrations—pianissimo— whisperings of death. A man passes a linden tree under which he has spent many warm, happy hours. He reflects on the initials he and his lover had carved in its trunk. As he turns to walk away, the tree turned gibbet murmurs: "Here you will find rest." The rustling of dry leaves, urging him back, toward death. It is difficult to convey properly the disquieting, seductive voice of that tree; it demands an extraordinarily delicate touch from the pianist.

"And frankly, I believe that . . ." T. said on the phone, and I heard: "Anne Frank-ly . . ." Then I thought about a novel where someone opts—chooses of their own accord—to live behind a wall in a secret chamber. (I want to die but I can't stop coming up with ideas for stupid novels.)

K. finally reached her limit. I am weirdly satisfied by her anger. She and I now agree how shitty I am. (She would never put it that way, think it categorically.) K. is kind K. is loving. K. is resilient. K. holds it together. So this is good. For her. I feel.

I go back to my barn. I drink. Despite my constant loneliness, I know, wisely, that it is better to feel alone when actually alone.

Once and for all.

Wandered in F.'s house. As usual I ended up at bookshelves. The parakeet was back in her cage; the cage back by the window. The light was colorless coming through by lace curtains. I marveled at his extensive poetry collection. There was a moldy paperback; a book of Zen parables, each recounting a tale of sudden enlightenment (in fifty words or less). Bottoms fall out of buckets, fleeting glimpses of the moon, slaps on the back from a keisaku, a phrase that explodes and then unifies the world. The ceiling falls in. Everything is nothing, nothing becomes everything.

Why do bolts from the blue seem so anachronistic? I need an epiphany. Divine intervention. How else will my condition ever change? How bad will it have to get? My satori will be an ECT. Or worse.

What if I wrote a note on a canvas, a good-bye, and then painted over it. Would that be sufficient?

92.

Still no events for the novel, no publicity. But there are a few reviews. One reviewer really got it. Understood the novel on its own terms. Satisfying. Another review was part-rhapsodic, part-quizzical, part-disappointed.

In the *important* paper, the book was assigned to a reporter who covers the city beat and who has written, specifically, about bikes. He liked the part of my book about bikes.

One guy loved my narrator. One despised him. Etc. Rorschach blots. I take it in, cumulatively, as failure.

My first depression hit me at thirty-two (at least, the first depression I had the necessary language to describe as such). My next was at forty-five. Then there's a depression every few years. Then every year. Last year there were two. This year, there have been four (if you can even consider them to have been discrete). The gap between episodes is being consistently halved. They are increasing in both frequency and, now, amplitude.

I'm a goner.

93.

Today I try to remember the hills and their colors. When the world was coming in. When I remember the hills and their colors now, I feel like how I feel when I remember my Social Security number.

Memoirists say—with regularity and, perhaps, false humility—that they waited to publish until all the relevant actors were dead. They did so out of delicacy. No one gets hurt. And isn't that so generous. But also, no one would be around to debunk. Provide contrasting evidence . . . Good memoirs, I think, should proffer

conflicting evidence, as life isn't so clear-cut. Diaries are different, of course. I proffer nothing here but the facts (but, of course, still: my facts).

I go back to that dilapidated river town. Loitering with intent. I do not see the man who wanted me to bite him.

Someone might find my story false, debatable, exaggerated, ridiculous, poorly reported. Reported in bad faith. My family and my oldest friends, in particular, if they were ever to read this, might have one of these reactions. It is always hardest for the people who have known you the longest to see what's there, through a fog of familiarity. A long interpersonal history provides camouflage. "What is 'familiarly known' is not properly known, just for the reason that it is 'familiar'" (is how Hegel put it). My newer friends and acquaintances, on learning what I've hidden, might simply be surprised.

I too am surprised. Surprised to be reminded, once again, about the self's discrete rooms.

(Eusebius. Florestan. E. F. E. F. E. F. E. F. E. F. E. F. E. F. . . .)

RB begins his book with this sentence: "It must all be considered as if spoken by a character in a novel." Maybe this idea was subversive when Barthes wrote it—the collapse of the distinction between fiction and non-. I work at a magazine. The journalists I work with are brilliant. I think they would find this notion false, or more likely indecipherable.

Today, I see, reading back, that my story could've been the story of someone overcoming adversity. Jesus, if that were true.

I saw a psychopharmacologist, years ago, during my "first" depression. I knew what the upshot of that visit would be. I would be put on antidepressants. I worried about what this new course of medication would change in me. Who would I be once my mind was altered (improved)? Anyway, the doctor was a greyhound: bouncing on his heels, skinny, with a little Vandyke and thick black glasses. He sat in a leather chair in front of an enormous black-and-white photograph of a New Guinea tribe. I instantly knew him for a type.

He asked a series of diagnostic questions. How was my mood? How was my sleep? Appetite? Any interpersonal conflicts? Any strange behaviors? Did I feel hopeless about the future? Did I feel or exhibit any suicidal tendencies?

It went on, and I answered as best I could.

Now I think my answers to these questions might constitute the most accurate portrait of the "me" that my critic friend had been after (when he said about my book, "What I want to hear about is *you*"). Though, of course, that wasn't what he thought he was asking for. What I think my critic friend was really saying was: "Don't be so pretentious."

R. is furious today. She let me have it, and she had every right. I listened. I wanted it. Like K.'s, R.'s rage also came as a relief. In this case, I had been given a rare opportunity. To dump my ego, care for someone. Perform a mitzvah. Hear, and help, my daughter. Someone I love more than myself.

Tell me everything.

She said her piece. I apologized. I told her I would get better; be better. More present. I said this, but what I meant is that I would try. She went to bed. I went to bed. I listened to the wind and the branches brushing the house.

"Why can't you be normal? I just need you to be a father." She's right.

The next painting is cadmium red (red-orange).

"But laugh laugh at me / Men everywhere especially people from here / For there are so many things that I don't dare to tell you / So many things that you would not let me say / Have pity on me." I understand Apollinaire, here. His blend of valedictory sorrow and bitterness. His frailty. I too have felt as though I have reached the end of my life (though I am only middle-aged).

I feel the door closing. I am scared.

94.

And another door is closing. Another clock ticking down. It is almost the time to return home.

Knowing this, I hustle.

And finish my last painting.

I am worried that all this work—this strange eruption of art—will end when I leave. There's simply no room in the apartment in which to make paintings, let alone store them.

I hauled all the paintings outside the barn today. I cured them in the sun and the brisk wind. There they were, canvases face up, strewn haphazardly in the back field. I knelt, shook up a can of aerosol varnish, and began to apply it. The wind was blowing hard, and so the finish dripped. It was thick and glossy in some places, or entirely absent in others, the overall effect spotty. But I decided it worked, this mottling. The terrible finish suited the paintings. Each was broken by fractures and fault lines, splintered like a puzzle.

I will, if I ever get to paint again, finish all my paintings exactly like this.

In my heart, though, I feel that painting, for me, is done.

Last day. There was a strong wind coming down the chimney. In the morning the windowpanes were framed by a frost come too early for fall. We packed. We cleaned. I gathered up the salvageable supplies and disposed of the empty or ruined ones.

95.

The drive was terrible. Kids elsewhere—far away in the back seats—K. next to me, headphones on. I was left alone again with my bullying mind.

Starting out, there were long stretches of wilderness. Then a shitty route through the unremarkable, midsized

cities, the byways of exurbs, suburbs. Finally, after five hundred years of compulsively tortured thinking, we were on the bridge, and then we were home. I dropped everyone, and then I returned the car to the garage.

The first thing I noticed on the walk back to the apartment—other than the sheer number of people around me—was the scaffolding. The walk took place almost entirely in a series of tunnels; warrens. They reminded me of photos I'd seen of First World War trenches. I had forgotten entirely about scaffolding. Evidently, after a pedestrian was killed by a loose brick (this was many years ago) the city adopted ordinances that require buildings to be inspected constantly. When defects are (inevitably) found, up goes the scaffolding. Often, the loose masonry or brick is fixed, but even after, the scaffolds remain, as it is expensive to reerect them after each inspection. It turns out that it is rare— exceedingly rare—for someone to be struck by masonry that falls off a building (rare to the point of statistical insignificance). The entire system, as it stands, is built on anxiety. We have somehow opted to live in constant shadow, almost underground, due to an irrational fear. Who does that sound like, I thought, entering my building, smiling to the doorman as if relieved to be back.

The apartment is a tomb.

The paintings, too big for the car, stayed in New Hampshire. Not one of them came with me.

96.

My depression continued throughout the fall and early winter, stretching into the new year, at which point we returned to the country.

Could this trip overwrite the last?

The answer to this question came quickly— unequivocally. No. And every morning I found myself shocked that yet another dread day had dawned.

Still, there I was.

I was there; still.

Alive. And I was back in the barn. The many paintings I had made over the summer were still stacked in another barn, one I had no inclination to visit.

It was so cold then that I could not feel my hands, the paint freezing in bottles and tubes. I had to keep large kitchen pots on a constant boil to reliquefy them. Which worked only partially. The paint still had to be forced through nozzles, blurted out under extreme pressure. It landed on the canvas loudly, rough with ice crystals.

My paintings would not set in such low temperatures, so I ran a hair dryer over them. The ice, when it melted, formed fissures and runnels in the slow-hardening paint. Scars.

The two old space heaters barely helped. I would wear three shirts, a sweater, two coats, and a pair of gloves. I could barely see, my hat pulled down to—and sometimes over—my eyes. This semiblindness was

good for my painting, I thought. And not only visual impairment. Painting with gloves on also added to the providential chaos in the work.

I trod up the hills alone, this time thigh-deep in snow. I had been living in a desaturated world for so long by then. But in February the world was truly colorless. Gray of snow, gray of forest, gray of sky.

I did the things one does when one is alive, if only the bare minimum. I breathed ("Don't forget to breathe"). I couldn't fucking stop myself from breathing, but it was as if the air were silted. Motes accumulated in my lungs. Always some dark residue left behind. A mass, building in me.

Several weeks of this.

The terrible days ran together and we left again. There were eleven new paintings. Those also stayed behind. Mummified in plastic tarps at F.'s with all the others.

97.

The week after returning to New York, I stepped off a curb on Riverside Drive and—almost, almost—into the path of a speeding truck. Aegeus and his slight tilt. (Only a bit too slight in this case. I was not ready. It should have been easier. It should've been done without thought. Like quitting an application, putting down a spoon . . .)

I stayed in bed for days, mostly crying.

The desire to be relieved of desire. The choice to no longer exercise choice. The will to relinquish will. Looking forward to never having to look forward. (Giving back what had been given.)

". . . risk of suicide is high; over a period of 20 years, 6% died by suicide, while 30–40% engaged in self-harm . . ."

I was finally done, but hadn't yet taken—and perhaps could never take—the final step.

An email went out to all my close friends about it all. The email was not from me. Mortifying.

At which point everyone—everyone remotely close to me—knew. And there was outreach from all corners. But no one could touch me, reach me, not truly, which begged the question: What was the point of that whole exercise? All it accomplished was to add humiliation to the mix.

The CEO on Zoom. I was on medical leave by then. He listened. "Well, everyone loves you here so much, so get well soon." Sweet. But what I was most grateful for was that, though caring and gentle, he seemed calm—not unmoved but not overly worried either. Like he knew that it's the pity that kills you.

M. and I had a standing FaceTime ever since I told him about my suicidal impulses. A great friend: I had to argue with him so that he didn't jump on a plane and move into the spare bedroom. His face was huge on the screen, mine tiny. I held out my tablet in front of me. I imagined him doing the same. His outstretched hand, my head on it: Hamlet, Yorick. He loves me dearly.

By the time spring came, the darkness had deepened, a thing that didn't seem possible. A hole beneath the subbasement. I was sure I would be hospitalized and welcomed it. I was forced (it's the only word for it) to see to a psychiatrist. Two days later I was given a diagnosis that shocked precisely no one but me. My therapist had been hinting at such a diagnosis for years.

A new med.

I experienced side effects. Though they were mild, they were frequent and disorienting. It is one thing to know that the meat in our craniums is the site of cognition—of everything that is and is felt—but quite another thing to feel the brain's autonomic mechanics at work. There should be a word or phrase to describe the particular psychological discomfort of suddenly becoming aware of such processes; as when the workings of, say, the circulatory system make themselves known through the insistent throb that attends quiet moments. Though

with the brain this feeling is infinitely stranger. (Körperbewusstsein?)

And it seems also absurd that a body can do anything without conscious supervision—make art autonomously, for instance—without our even noticing.

The doctor told me about one side effect for my new medication: exceedingly rare and dangerous. I told him I'd prefer not to know, being impressionable. He told me he was required to tell me. I said no thanks. He insisted. Okay then. He said that there is the potential for a life-threatening burn that can develop throughout all my mucous membranes, eyes, mouth, anus. Bring it on, I thought.

I still couldn't sleep. The only thing that helped me relax was imagining hiding places. Secret passages, shadowy nooks, forts, blinds, camouflage . . . I imagined myself nestled in behind a wall looking through a portrait's eyeholes ("Anne Frankly . . ."). This, for some reason, comforted me.

What would constitute an art form or artistic practice in which one could hide?

Once I could leave the bed again, I rented a studio. I would be alone there. It would be a place where my depression could harm no one. Also, I would paint again.

I was amazed how much less expensive it was to rent on the Upper West Side than it was to rent in Brooklyn, which was completely out of my price range. Who wants to paint in Manhattan anymore? No one cool. Perfect.

Still, the studio was shabby. An ugly place. The top floor of a walk-up. Washed-out light from two narrow dirty windows. Plastic (faux-wood) floors and cabinets. Flaking walls. Strange odors. No heat or gas.

I made the space my own. I wrapped the standpipe with rope. I pulled off the cabinets and tacked linen over them. I tiled the walls of a kitchen so narrow that you could not turn around in it (enter forward, back your way out). Postcards and photos of my family (whom I barely saw throughout this period) were taped to the bare walls. I brought in a small, cheap two-seater couch and an equally cheap ottoman. A daybed I made out of tatami mats went on the floor. A small futon. I clipped painter's lamps (like the ones I used in the barn) to the radiator and to the listing mantel of the nonworking fireplace. I put a bead curtain over the entry. I taped some dried flowers to a wall. I don't know what these flowers are called: long stalks with perfect yellow orbs at the ends. (Are they flowers?) There was a sisal rug, which was immediately splattered with color. Tarps on the floor everywhere else. Easel. The room filled up with paintings. Big and small, vertical and horizontal. I'd propped the biggest of these paintings against the couch and the radiator. I hung them also, floor to ceiling. The walls were no longer grubby but bright. The space was by then, by any objective measure, pretty. Stylish. It looked like an "atelier," I thought. I bought a blue grocer's apron and so looked more the part. I didn't really care about these upgrades so much, but at least I was not embarrassed to have visitors. I had visitors.

Suddenly I needed them, these visitors. I began to talk about my condition. (A bipolar disorder: right?)

I took pictures of everyone who visited the studio. They would sit on my small couch opposite my rickety chair.

At points, I would look at my paintings all around me and think: These are the stones with which I built my bulwark?

Then I began to sell them. A fair number of them actually. This was a surprise. I was bubble-wrapping, drawing up invoices. I'd take them over to the local shipping center and send them off to L.A., Moscow, all over.

In pain but at work. It should say this on my business card.

J., an old friend of my father's, spoke with me about my father's despondency, his desire to die. J. mentioned an incident with a gun. I was so shocked by this new information I got off the call as fast as possible. I never asked a single question. Another attempt on his own life, I presumed. (Or maybe another attempt at an attempt?)

I tried to teach myself the proper way to stretch canvas. I procured it in long rolls. Stretched and stapled these canvases poorly. I have no patience. The results were uneven, the ends of the canvas were torn. But you can only see this if you flip the canvas over. The tearing is now visible only on their backsides.

The paintings became . . . drippier.

Roland Barthes died in February of 1980. Hit by a truck. (Not on purpose.)

Earworms, idées fixes.

Grief is persistent, repetitious, often shocking. But rarely informative.

Answers to explicit questions are informative. My father was irrecoverable, which used to evoke in me every manner of feeling. Then, and now still, it only evokes one: curiosity.

A sentence may have the structure of profundity without being, in fact, profound. Reading back the journal, I worried about each entry. Also felt this way about the paintings. I began to dab at the older ones. Just a few. A few touches here and there. Botox.

I took a walk with E., another one of my father's oldest friends. He said to me, about my father's lability: "You never knew which man you would get, and you would more often than not guess wrong."

E. also told me that, growing up in the Bronx, my father's bedroom looked out on a cemetery. E. said my father was morbidly obsessed from a very young age. Notably so.

RB was the last writer I'd read before the depression and its concomitant withdrawal. Barthes was a reluctant diarist. Not just a diarist of the quotidian but a philosophical diarist. Theorist, writer, pianist, a devoted son. He was always, asymptotically, approaching the first sentence of a novel he never did (could) write. I treasured all of it. His little "mythologies." His joie de vivre, his tristesse, his finely tuned philosophical and aesthetic sensibilities . . . Can you choose who it is you love?

Will that book of his be my last book? My final read?

I put my paintings in the bathtub. I went at them with the rough side of sponges. Steel wool. Soaped the paintings, let them soak. The bathtub was always stained at the waterline and rimmed with flecks of color. The color of the day's work.

After the outer layers were stripped from a painting, exposing the ones beneath, I would stand back and assess. If I saw anything then that betrayed the human hand at work, I felt real frustration. All I wanted from these paintings was proof that I had nothing to do with them.

The canvases barely survived these vigorous scrubbings. I painted over the wounded surfaces. Buyers would ask if I wanted their framers to patch the holes in the paintings they'd just taken possession of. I always said no.

I made about four or five new paintings a week.

Schumann had other heteronyms, other names under which he composed, including the commedia dell'arte figures Arlequin, Pierrot, Pantalon, Colombine. (The "bi" in "bipolarity" is reductive, of course.)

I was feeling more and more that my *anxious* self was not really a self but a feeling: a knot in my solar plexus. (As I'd said in the diary, perhaps all my selves are bodily sensations, and at that point I duly attempted to locate each one of these selves in my body. To reduce them to physical complaints and remove the stench of psychology from them.)

Silted air still, but not psychologically silted. Actually silted. Sedimentary buildup. The studio's dust shading the wet canvases.

None of my pain was *visible* in the work. All that was visible in the work was the work.

I was, then, worn down by being worn down. Like being jet-lagged after traveling from your own bed to that same bed after never having left it. Too tired even for depression.

I was still forgetting to eat. Living on bananas and nuts. Food for the enisled.

How to sleep? Not even my secret rooms, hideaways, mental bolt-holes could help. I tried to remind myself of the procedures and techniques. This is, of course, totally counterindicated.

My new doctor had an odd name. It sounded like the cognate of a more familiar name. I asked him about it. Indeed, his name was a cousin of the name "Barthes." I told him that Barthes's book was the last book I'd read. He replied that he had attended the Sorbonne and had been due to attend a class of RB's, but that class was on the very day Barthes was run over in the street. (The final lectures Barthes ever gave were on "the preparation for the novel." Lectures on the novel he intended to write.)

The doctor said I was thin. I'd lost sixteen pounds since my last checkup. I asked him about my back, which had been hurting. He told me I was hunched over. When I stood and when I sat. All those years at the piano. I like being close to the keys.

Something new arose. A shape. A bent back. Like a J but upside down. An arch? I realized that it wasn't a singular shape but composed of two distinct lines, rising

up to meet each other. At the top juncture the lines were knotted together in a scribble.

More of these shapes. I didn't know what to call them.

I'd stopped wearing my glasses early on in the depression. I put them on again.

I wondered if my works were to "paintings" as "pics" are to "photographs."

I had this line of Bill Haydon's from *Tinker Tailor Soldier Spy* in my mind frequently: "Awful daub, really."

Awful daub. Awful daub.

All I listened to while I painted was baroque music; a lot of Sylvius Leopold Weiss, a woefully underappreciated composer. Anyway, his lute music is glorious, but its emotional bandwidth is narrow. Beauty, but not the kind of beauty that makes one cry.

I was outside more. Especially in the late, icy rains when the sky weighed a ton. When the few people outside were also hunched over.

Still, my hitching, telltale breath.

Painted a knot.

Then everything was wet. I painted fast and wet. Nothing allowed to dry, so no color remained a single color. Every sopping brushstroke contaminated all it touched: pinks turned to yellows, grays to purples, blues to whites . . . Every moment of the canvases was an interruption. There were no backgrounds and no foregrounds; no shapes, only gestures, brushwork.

Nothing to see there but a color breaching its boundaries and being invaded in turn by a neighboring color. (Wet painting! Nobody told me.) Words were the least of it then.

So many (prescribed) pills. Two white tiny ones, one huge white one, one small brick-colored one, a blue one I needed to break in half. Every morning they tumbled into my palm. Sometimes they fell on the floor. It was easy to miss one. Some mornings my hand shook and then all bets were off. I think of all my mother's pills. They arrived in a package that her pharmacy sent each month. The package—with its little compartments for each day—looked like an advent calendar.

Parkinson's makes my mother smaller every day. My father's illness made him larger. Heavier, puffier. The existential size and weight of him.

I stopped drinking so much. My doctor told me I had to. And one day I reached for my last—and newest—stash of painkillers only to find the remaining bottles were gone. Had K. thrown them all out? No. Had the kids found them? Impossible. I was stumped until I remembered that I had thrown them out myself a week earlier. While high.

By the middle of the spring, I resolved to have made one hundred paintings (including those I'd already finished). I'd do this because I could. I knew this, because, by then, I'd already reached such a high number of works that I could extrapolate from the rate/time it had taken me to achieve what I'd made thus far. Those listing piles of art all over my floor and walls.

For periods, the despair would fade a bit, and then the paintings came slower, when they came at all. Many

were aborted. The rate of production fell. As ever, it is cheap and easy to draw a conclusion from this fact.

Still, I worked, and new paintings arrived, albeit reluctantly. As had always been the case, I took no bearings artistically. There was no program.

I began listening to other music. The Second Viennese School. Webern in particular. Spiky stuff. I listened to Webern because he was a miniaturist and an atomist, but also because he proposed a music that comprised not feeling but rather sound.

During this period, I began painting ladders. The first ladder—painted on a metallic gold background—lists far to the right. It is a rubbery ladder. Structurally unstable. Comically so. The next ladder was more or less straight but ended nowhere. It brings the climber up to empty space. It is painted on a very tall canvas. This ladder descends from the top edge and abruptly stops before reaching the bottom one. Meaning that if you were to climb down it, you'd get stuck. (Or, if you'd attempt to ascend the ladder would be too high to reach.)

Anne Truitt described making her art as "not knowing where I was going but knowing how to get there." Me, I had no idea where I was going *and* no idea how to get there. The only thing I knew was when I had arrived.

More arrivals.

I landed on something else: an unreadable alphabet. Letters (glyphs) lined up on a grid. The painting looked like an ABC primer for alien toddlers.

An alphabet, as RB points out, is a set of fragments. I find it interesting that no one fragment (letter) bears any

necessary relation to its immediate neighbors; unlike say, the periodic table (groups, periods), a QWERTY keyboard (spatial relations), or the notes of a scale (leading tones, etc.).

Looking now, I see that the grids were also calendar pages.

I was lucky with the parents I was given. The circumstances in which they found themselves were difficult, terrifying, and they faced it all with courage. I am lucky in so many ways. In most ways. Perhaps in all the ways. This is what I thought one afternoon. I think this now.

I saw my mother almost daily. My studio was close to her apartment (another reason I chose the location). Seeing her condition worsen was awful, but I realized one afternoon while cleaning something in her apartment that this small act of cleaning provided me with even more relief from the depression. A little respite.

I began to feel glad that I was the only family member caring for her. I even worried that someone might suddenly step in. This was never going to happen, but still, the feeling is embarrassing to recount. My desire for ownership. Or for some species of valiance.

I made a bright set of lines on a dark linen canvas. One brush in each hand. Kinetic. I thought of calling it *Choreography*, because my hands were dancing while I made it.

Then a hard, black shape on an untreated canvas. I had taped out the shape so it would be geometrically perfect.

After this, the paintings were "about" "two things" and "two things" only. I didn't know what the "two things" would be, one to the next. Two shapes/colors, etc., neither interacting with the other, unaware, as it were, of each other's existence.

There were moments when I saw color in the world again. When everything on the street was a color. And I realized one morning when attacking a fried egg with the side of my fork that every gesture I made, every time my hands moved, I carved the world into new shapes. Obvious, but I'd never thought it until then. That afternoon I hailed a cab and cut a long vertical arc with a chaotic little tail into the buildings and the street and wondered if I liked the line. (I did.)

How long would this period of seminormalcy last?

There were too many paintings to store in the small space.

More visitors. Sometimes they come to have a coffee with me, cheer me up, bolster, lend support. More people come to buy art. One day, a man, H., who is somewhat prominent in the art world, sat on my couch and inspected all the work.

"These are great, but you are doing it all wrong," he said.

"How so?" I said (thinking, as I always have, of the infinite ways I could be "doing it all wrong").

"You need to pick one thing, one style, one technique, one idea, and just do that one thing over and over and over again. You need a brand."

This man did not know me, as a person, at all.

I started practicing the piano again. I printed out the entire *Art of the Fugue* and pasted its oversized manuscript pages onto large cardboard sheets. (The work is not written for a particular instrument—it is a purely ideational composition, not a performance piece, not a piece for mortal hands. It is, in the philosophical sense, purely analytic. What a mathematician might describe as a "beautiful equation." If such an equation could also plumb the depths of human emotion.)

Eventually I finished learning this piece, inasmuch as anyone could "finish" learning it. I just mean that I could play all the contrapuncti, and play them well, hearing all the voices at once. All the voices. Sometimes foregrounding one, sometimes another.

"Piano" is an abbreviation of "fortepiano." "Fortepiano" expresses not one idea ("piano") but two ideas: "piano" and "forte." Soft/loud.

I kept painting in diverse ways, trying new, stupid techniques, expressing new, stupid ideas. Each canvas seemed an opportunity to make something unexpected. Maybe I'd land on the "one thing" that the art expert had encouraged me to pursue. But if I didn't, who cares? Where in the world—in the real world—is there this "one thing"? (Show me something that is one thing!) I make another small painting that is called *Two Things*. There are actually three things on the canvas, and so the title *Two Things* struck me as a pleasingly confrontational. (As of this writing I've added a "fourth" "thing' to the canvas.)

Also continued to add and subtract from the journal. One night sitting at a bar (drinking a seltzer and lime) G. gives me: Nachträglichkeit. The aprés-coup. Afterwardsness.

I've *touched up* some of the old art as well. And I erased and rewrote some of my old signatures.

The cost of looking back is the constant need for improvement.

98.

Then, alone in the studio one morning, I realized I was going to finish. Begin and complete my hundredth painting. Not finish it "one day" but finish that very morning. Having counted again just to be certain, I knew the next painting would be the last.

I went outside again before beginning, took my time returning to the studio, and then began. It was completed by late afternoon. After, I took a walk in the park. Sat on a bench by the museum. I wasn't sad. I wasn't happy. I was simply done.

One hundred. It hadn't been some show of artistic virility. And I'm no marathoner. I'd pegged my recovery to this number.

The last painting was called *Summit*. It is the wrong name. I was atop nothing, and there was no vista.

The background of this painting was made from pages of an old book I owned called *The Peter Principle*. This book is famous for this adage: "One rises to the level of one's own incompetence." The book had fallen off the uneven studio mantel onto the floor beside my paints, and the binding was already broken, so I plundered it

for paper. The title and the adage, believe it or not, had nothing to do with my choice to incorporate it into the work. Like my pink painting from New Hampshire, the material was ready to hand.

Those loose pages were glued onto the canvas and then painted over. Some of the paint was applied with my palms, etc. My fingerprints are literally all over it.

Yet the painting was less a painting than a collage.

I knew, as of finishing that work, that no matter what, I would have accrued some record of my lost time. A record in art and a record in words. A record of those eons. What I had made may be good art, or may not be. But still.

The building housing my studio needed work. The facade was crumbling. The hall smelled of rot, the badly painted walls of the stairwell were a color not even I would add to my liberal, ever-expanding palette. The gas had conked out again. The bathtub faucet spat black clots. I started to notice construction workers. Scaffolding went up. Plastic was secured over my windows so loose masonry wouldn't get in. Meager light became no light. The studio was officially sealed. I needed to leave. It was time anyway.

The unsold paintings went into storage. All the supplies—palette knives, canvas, stretchers, frames, paint, turp, pens, oil sticks, pencils—went into industrial-size garbage bags and were thrown to the curb.

The final day I went back to the studio for one last clean. I unlocked the door, walked in. Broken branches and rainwater were all over the floor. The ceiling has collapsed. Truly collapsed! My old studio was open to the sky. There the sky was. I laughed a lot. Went

downstairs and was handed my security deposit by the landlady with barely a word exchanged.

I took a few paintings home. Only a few. Four. Hung a small one above the piano, two larger ones on the living room wall. The one I had once called *Mykonos*—the blue-and-white self-portrait—went above the bed. That memory (of being on that island and of holding my life cheaply) had ceased to evoke anything in me. Each morning it evoked less. The painting had become an abstraction.

I began, tentatively, to write a new novel.

I worked my job during the day, practiced music at night, wrote in small, interstitial moments (mostly on the subway).

My mother and I were spending longer and longer periods in each other's company. And it became easier to speak about the past.

"Do you still think about Dad?"

"All the time."

"His suicide attempts: Can we talk about them?"

It was the first time I had ever broached this topic.

"How many were there?"

"One."

"But what about . . ."

"Oh, two . . . ?"

She told me that the night of his first attempt she had been asleep. He woke her in the middle of the night in a panic. He had shouted, "Call an ambulance, call an ambulance."

Mom said to me: "Imagine how alone he must have felt."

"He hadn't been ready then," I said. And she nodded. This I found devastating. His not having been ready. (Is there something about a suicide's certitude that is reassuring?) I felt gratitude for my not having been ready. Or more accurately, for knowing I'd never be ready.

"Do you think he died from a final attempt?" I asked.

"He was in a coma, there was a pneumonia . . ."

"It's not important, Mom, sorry."

(But why was it so important for me to know the *how* of it? What did it matter, ultimately. What was done was done. And yet it did matter. To me. It mattered. Very much so. My not being told this fact seemed like the worst of all elisions.)

"Please remember the good things too, Peter."

"I do, Mom. I remember."

Writing the new book, I could see when editing that, as with painting, nothing is erased. Chapters and passages are not—at least not completely—deleted and replaced, and the outcome of such editing is closer to overpainting than I first believed. Whatever words I thought I'd removed would leave traces. A pattern, a topography. Little ridges, accretions. Some color would remain, tinting the sentences that went atop the old. And sometimes I would scrape back the new and the old would still be there, but slightly altered by the reversion. I haven't written enough music to know if this is true with music as well. But I suspect it is.

99.

I realized long ago that it is difficult for me to keep my eyes forward—my head erect—when walking down city streets. The downward gaze of deference and shame. ("The individual may experience crying and have a negative outlook on life and poor eye contact with others . . .") But I had begun to look. To look around me. To look at people, examine them. And people would not seem to care that I was doing so. I could never paint a portrait, but during this time I thought of these moments, observing other people, as "sittings."

I kept going to the office every day and my energies at work were renewed (more or less). I did not paint, and with each day that passed I was even more sure I never would paint again.

I ate, I slept. I read.

Specifically, I read Roland Barthes's *Mourning Diary*, which, somehow, I'd never got around to.

Barthes writes: "Everyone is 'extremely nice'—and yet I feel entirely alone (*abandonitis*)."

I grew less sensitive, though some mental habits persisted. The pathetic fallacy for instance. It was still the case that objects had souls, and taking an apple from the full bowl was like enacting a family separation at an auction block (a horrifying image, but it was what I would think).

F. incorporated a line into his wedding vows: "Love is not a feeling; love is put to the test." Though Wittgenstein meant something quite technical here (he was making a point about grammar), it struck me that the way in which F. understood this sentence—love being meaningless until tested—was also correct. When I'd wash my mother's dishes and fix her computer, or lift her walker over the saddles of doorways, I'd think of this line proudly, like I had passed.

Days and days.

I own a particular work of my father's. It is one of the first things you see coming through the entranceway of my apartment. It hangs alone on a white wall, high up, and

slightly off-center. It is my favorite of his works. It is my favorite because (and it sounds terrible to say—terrible, a blasphemy) I feel that it is my father's only truly successful work of art. I have, I realize, grown out of the belief that his art was special in any way. (How nasty does a person have to be—how disloyal, spiteful, heartless, clinical, disrespectful—to say such a thing about his own father's work? It was impossible for me until this very moment to write such a thing down. Now that I have done it, I feel I'm due some punishment. Yet I also feel for certain that it is true.) He was not a successful artist. (Certainly not in the financial sense, but I mean his art does not really succeed as art. It almost does. At times it seems to.) But his work is neither original nor particularly interesting or arresting. Neither is his work truly beautiful. It looks and feels shackled—in thrall to a critic, an inner critic, and therefore it is self-conscious, overworked, overthought (in the docket). Some of his works have a boldness about them, but now this boldness seems put on to me, a kind of puffing up. A pretense of confidence. Of course, who could be so critical of others, as he was, and not direct that same criticism inward (though perhaps the order was reversed)? I suppose true narcissists can do this (critique only the work of others). Or critics who are merely critics, rather than those who make things themselves.

Again, I make no claim that my art is successful either. This feels important.

But this work of my father's hanging in my apartment is sublime. When did he make it? Before the illness? During? In the throes of despair or in a moment of respite? And how did I come to own it? After his death the members of my tiny family scattered away into our respective silences, and his possessions went where they went; no plan or oversight.

The piece is small. It is both a painting and a collage. Almost entirely black. Not just black but "rich black." Deep black. A heavy and impenetrable black. (This black is the only painted element.) I wondered one morning how he had achieved such a black. Did he have access to paints I didn't know of? Some special light-repelling pigment? I'd never seen such a black—in oils or in acrylics. It absorbed all energy; a void-plane.

There is only one other element in the work (other than the black field), and that is a photograph—a portion of a photograph neatly trimmed into a narrow rectangle. I do not know where this photo came from, whether it was a photo my father took or one he found. All that's in the photograph is a dark room with a single open window; the window lets in a hazy, gentle, morning light. It is Vermeer's light, though in this photo the light shines on nothing but the empty room. ("Shines" is the wrong word for both Vermeer's light and the light in this photo. Vermeer's light doesn't shine, does it. Vermeer's light—like the light in this photograph—annunciates. It sanctifies, rather than reveals/exposes.)

The morning when I stopped in front of this collage/painting to wonder about the black and the window was the first time I had really looked at it. Impossible, right? I'd lived with this artwork for thirty years. And every day it hung there (almost in the corner, like a Russian icon). But I'd never looked at it with an artist's eye

It is good; very good, I thought. And then I saw that the composition was almost entirely negative space. It is 70 percent empty. A dark field. With a single egress; a small conduit to the outside world. A slim possibility of grace.

The painting has no title.

Days and days: months.

A journal is, of course, "from" and "to." Everyone knows this, though I hadn't.

When rereading my diary, I found myself, once again, moving clauses, amending, fixing timelines, making sentences more melodious . . . I felt I was adding yet another layer of fraudulence. Though I persisted.

I reread *RB by RB.*

Two of Barthes's entries concern an age-old philosophical thought experiment, which goes as follows:

The *Argo*—the ship of Jason and his Argonauts—is so battered after each voyage that it requires constant repair. Is always in the shop. So every time it returns to harbor, it gets new parts; replacement parts. New masts, new planks, new sails . . . Eventually, every last bit of the boat has been replaced and the *Argo* becomes like a jacket made entirely of patches. The question: Is the *Argo* still the *Argo*? In other words: What constitutes identity? Barthes is interested in the idea that identity in such cases comprises (merely) a name and a structure. Anyway, I was baffled reading this. Barthes either got it wrong or was being cheeky in some inscrutable manner. The thought experiment is actually known as "the Ship of Theseus" (referring to the ship that carried Theseus back from Minoa—the ship King Aegeus saw from his promontory).

"Argonauts"; "the Ship of Theseus." Did Barthes (Maggie Nelson) apply the thought experiment to the thought experiment? Is identity *less* than a name?

(Surely these writers knew something I do not?)

Is identity the sum of our memories? Like the Ship of Theseus, is our *first form* our truest form? Is that where quiddity hides itself? Beneath time's modifications?

I gather that the current "Ship of Theseus" Wikipedia article retains not a single sentence from the entry as originally written.

I walked by the building housing my old studio. The scaffolding had come down. The entire building looked spiffy. The brick repointed, new window casings. Spruced up. I doubted that the interior had received a similar overhaul; that the hallways had been repainted, the smell eradicated. I bet the units were still derelict and dark. I felt sure of this, seeing the new facade. Then I thought maybe I was wrong.

Days and days.

To not sink to the bottom. But also: to not surge forward.

Days and days.

Then.

Unnoticeable at first, something bright. Glinting. Like an open, gold cage.

Barthes said this in *A Lover's Discourse*: "The last word may be replaced by an incongruous pirouette."

One day I woke up and the world was promising.

I caught someone's eye and smiled.

———————————

PAINTING 100

Opposite:

Paper collage of pages
from the first edition
of <u>The Peter Principle</u>

Book pages, acrylic,
acrylic pen, pencil,
Sharpie, Wite-Out

Afterword

Of course, nothing is so simple.

A few months after completing this account, I placed all my paintings into a preliminary layout for a book (this book).

There were 106 of them. Huh. One hundred and six does not make for such a tidy ending now, does it.

More important: What to do with the (superfluous?) artworks?

I decided to curate what I had. Some made the cut, others didn't. In other words, there are precisely one hundred works of art reproduced here, but you must imagine the excluded ones, outside, as it were, the frame.

But then . . .

I counted the paintings one more time (this was much later) and discovered I'd painted 112 of them.

Now, having counted once more: 122.

Mea culpa?

Sure. Though now I think on it, this state of affairs seems perfectly apt. This is, after all, the story of someone who had put his head down and, when he finally was able to look up again, discovered that there was more in the world than he had believed there to be.

So, excusing the poetic license, the excess—as with all excesses here, including but not limited to the very project itself—feels right.

<div align="right">M</div>

Acknowledgments

I would like to thank, first and foremost, my mother, who passed away the week of this book's final edits. She was one of the—if not *the*—most beautiful, loving, gracious, graceful, generous people I've ever known, and I will miss her as long as I live.

I would like to thank Karla, who stuck by me, against all reason, through these depressions. She picked me up every time I fell down, always ready to step into the breach when I was unable to function. Always there, always helping, always listening, always searching for ways to alleviate my suffering. Somehow she never stopped loving me despite the incredible burden I put on her. That she did all this defies belief. Except it doesn't, because that is just the kind of person she is. She is what kept me going.

I'd like to thank my children, Ruby and Violet. All I can say here is that I am sorry in two different ways: (1) Sorry that I may have caused you anxiety or grief or loneliness or confusion during this period, and (2) sorry that I am (to quote one of you) a "total drama queen." I'd like to think that having written this book, the drama is all out of my system.

I'd like to thank Ruth Cohen, who listened to me and advised me week after week, year after year, with such wisdom and intelligence, such infinite patience, with a practically eidetic memory, good humor, and compassion, and always without judgment. It is not an exaggeration to say that I learned from Ruth who I am. What a gift to give someone.

I'd like to thank Dr. David Gutman, whose treatment and care were invaluable to me. I am so fortunate I found him when I did.

I'd like to thank Kendall Storey, my brilliant, brilliant editor. Whatever possessed her to take on such a weird proposal? How did I get so lucky? We will never know. But what she has done here is remarkable. She made this book so much better than it otherwise would have been . . . No, no, actually, she made this a book, full stop. Thank you, Kendall.

I'd like to thank Chris Parris-Lamb, my agent. I find myself, with every book I write, more and more surprised that I am still fortunate enough to be your client. I've given you practically nothing in return, every book I've written being stranger than the next. And somehow you still believe in me and seem to like the things I make. *Why, Chris, why?* As God is my witness, someday I'll write that bestselling romance novel for you. I promise.

I'd like to thank everyone at Catapult. Wah-Ming Chang, Olenka Burgess, Laura Berry, and tracy danes in production . . . What an incredible job you all did making this book. I know exactly how difficult it is to build a thing like this, having worked in publishing myself for so many years and produced a book or two in my day. There are few teams, anywhere, who could've pulled this off, done such an incredible job to such exacting standards. I'd also like to thank Elizabeth Pankova for her editorial prowess; Lena Moses-Schmitt and Megan

Fishmann for their great publicity know-how and buoying enthusiasm; the incredible design team, Nicole Caputo, Victoria Maxfield, and Farjana Yasmin; and the fantastic marketing squad, Rachel Fershleiser, Ashley Kiedrowski, Alyssa Lo, and Lily Philpott.

I'd like to thank the folks at Janoff's, the small art supply store on 111th Street and Broadway. Janoff's has, improbably, been around since 1954 ("Janoff's Typewriters: Sold, Bought, Rented, Repaired. Drafting Materials, Art Supplies, Greeting Cards") and is still a wonderful resource for artists. I'd especially like to thank Jerry Ma, an artist himself, who provided me with advice, and all the materials I needed to make . . . whatever it is I've made here.

I'd like to thank all of you wonderful people who bought paintings of mine. I have a strict no-return policy.

I'd like to thank my friend Michael Theodore. There was never a moment when I didn't feel his love and concern. He checked in on me, cared for me, comforted me, guided me, encouraged me, believed in me . . . Well, there are no words.

And lastly, I'd like to thank you, Dad. What a fucking lousy hand you were dealt. I love you.

<div align="right">Peter</div>

© Maria Spann

PETER MENDELSUND is the author of seven books, including the novels *Weepers, The Delivery,* and *Same Same* and the nonfiction works *What We See When We Read, Cover,* and *The Look of the Book.* He is also a renowned cover designer and the creative director of *The Atlantic.*